SAFARI
JOURNEYS THROUGH WILD AFRICA

ARI

JOURNEYS THROUGH WILD AFRICA

PHOTOGRAPHS: ADRIAN BAILEY
WORDS: ROBYN KEENE-YOUNG

Contents

Preface	7
grassland Serengeti, TANZANIA	8
forest Bwindi, UGANDA	44
wetland Okavango, BOTSWANA	80
desert Namib, NAMIBIA	112
river Zambezi, ZIMBABWE	146
mountain Table Mountain, SOUTH AFRICA	186
Acknowledgements	222
Contacts	223

(Half title page)
Walking trail,
Mana Pools, Zimbabwe.
(Title page)
Wildebeest,
Serengeti, Tanzania.
(Opposite)
Lion,
Okavango, Botswana.

Preface

Early in 2005 we approached our editor at *Getaway* magazine, David Bristow, with a proposal to put together a series on Africa's ecosystems. The idea was received enthusiastically and, after the usual bit of haggling, we set about putting together the travel arrangements, now with a deadline suddenly looming. The features were published over the course of a year – from August 2005. This book is the product of the 43 days spent on assignment for that series, with one important difference – space.

Magazine editors face the daunting task of juggling editorial and commercial space, as well as finding the right balance in each issue. This is something that constantly frustrates us, as the take from an assignment is usually so much more than can fit into the four spreads of a standard South African magazine feature. But in this book, we have the freedom of 224 pages to reveal more of our journeys, to describe more experiences and to show you more images.

Each chapter consists of two parts: *Getting There*, a record of the delights and trials of travel to our destination, with images mostly shot directly from our moving transport; and *Being There*, documenting the time spent in each region.

There is one further distinction between this work and others. After our first few days in the Serengeti, we knew that if we continued exploring each ecosystem from the seat of a 4x4, we wouldn't achieve much intellectually or spiritually. So we decided that from that point on, where possible, we would leave the prosaic comfort of a motor vehicle and shoot each story on foot, or at the very least, under our own muscle power. We hope this self-imposed exposure shows you a more intimate view of this wilderness. This is Africa, unplugged.

Adrian Bailey & Robyn Keene-Young
May 2006

Serengeti

GETTING THERE

IF YOU COULD CHOOSE ANYWHERE IN THE WORLD TO HAVE YOUR APPENDIX BURST ON YOU, Arusha, Tanzania, would probably not spring immediately to mind. It hadn't for Adrian Bailey, whose long-awaited first visit to the Serengeti National Park was only hours away when the untimely eruption of this useless bit of anatomy put him on the next plane to Nairobi, Kenya. This was after a brief consultation with the hotel 'doctor', whose tools of the trade included a white coat and a supermarket packet containing a stethoscope. 'I have these drugs,' he offered, digging out pills for headaches, heartburn and diarrhoea from his coat pockets, 'which would you like?' The next doctor volunteered to operate under local anaesthetic. Adrian is still not sure if he was joking.

Five years and one appendectomy later, we were both staring at the snowy wig on Kilimanjaro out of the aircraft window. I was tremendously excited about my first visit to the Serengeti. The name itself was so evocative, so mythical, I'd been repeating it at every opportunity, telling anyone who'd listen: 'In July we'll be in the *Serengeti*'.

Moses Akyoo, our Wild Frontiers guide-cum-driver, collected us from Arusha's Kilimanjaro airport. My excitement soared at the sight of the vehicle. It was one of those classic East African safari jeeps, the kind with the pop-up roof. Wow! After a decade of southern African ersatz safaris I'd finally be embarking on the real thing, the original, the authentic, the world-famous Serengeti Experience.

(Previous spread)
Wildebeest,
Musabi Plains.
(Opposite)
Cattle with herder,
near Arusha.

And there was a Maasai! My first. Walking past a field of sunflowers, draped in a red toga, called a *shuka*, his feet clad in sandals fashioned out of rubber tyres. His white-beaded earrings were of such impressive dimensions that they strained his stretched earlobes. Instead of the traditional spear, he carried a wooden stick and walked with a purposeful, stiff-backed stride.

Shuka stall, Mto Wa Mbu.

We'd arrived in Tanzania's safari capital in time for early-morning rush hour. Men pushed wooden wheelbarrows loaded with green bananas and white bags of charcoal through streets choked with battered trucks, run-down pick-ups and minibus taxis called *dala dalas*. Some of the wheelbarrows had handwritten registration plates and boasted Turbo or 4x4, while the taxis flashed names like Passion or Slow But Sure (if only) on their windscreens. Passengers hitched lifts on the running boards of overfull *dala dalas*, looping their arms through open windows. The rules of the road seemed open to interpretation and hooters were honked with abandon.

Roadside stalls and pedestrians crowded the pavements, the women bearing children on their backs and parcels on their heads. On the far side of town I noticed streams of women dressed in bright wraparound skirts, called *kangas*, wearing empty plastic buckets like handbags. 'They're going to harvest coffee,' Moses explained. And soon we came to the sprawling estates, where coffee plants flourished under the shade of towering trees.

Finally the frenzy of town subsided into the gentle pace of rural Tanzania. Not far out of Arusha, Thomson's gazelle, ostrich and zebra shared the grasslands with cattle. On the right-hand side, Mount Meru peeked at us above a bank of cloud; on the left the flat landscape, where stunted acacias squatted, stretched to eternity. The bright colours of the city were now supplanted by the muted shades of dry-season Africa. Yet Maasai men and boys stood out starkly against the arid, overgrazed plains. Plumes of dust floated around red and purple stick figures that shepherded cattle and goats to muddy waterholes, where women washed clothes and watered their donkeys. I was intrigued by the 101 ways to wear a *shuka* or a *kanga*: as a dress, a skirt, a two-piece outfit, a headscarf, a baby-holder, even over a T-shirt. Matching wraps were definitely a no-no; the louder the better seemed to be the trend.

General dealer, near Makuyuni.

There was an alarming number of tour buses sharing the road with us. But I consoled myself with the thought that they couldn't all be heading for the Serengeti. Popular tourist spots like Lake Manyara, Olduvai Gorge and Ngorongoro Crater all lay along the same route. This tourist traffic also sustains rows of roadside stalls selling curios and *shuka*s to eager *wazungu* (singular = *mzungu*; white man, or foreigner). We had it on good (Maasai) authority that you should never pay more than US$5 for a *shuka*. The going rate was US$15. Adrian, as it turns out, is a poker-faced demon at bargaining. I would sooner have paid double the asking price than hear myself saying, '*Ai*, my mother will beat me if I pay so much. I'm an African brother, not a rich *mzungu*, I want an African price.' 'You are killing me, my friend,' complained the shopkeeper, after a lengthy and amiable negotiation during which we settled on US$30 for four.

A couple of hours out of Arusha, Moses pointed out the imposing barrier of mountains that lay ahead. This was the wall of the Great Rift Valley, formed over 30 million years ago when the bottom literally fell out of the earth's crust. We occupy a restless planet where millennia of tectonic bumping and grinding have weakened the earth's surface, allowing huge chunks to drop between fault lines, forcing up molten rock and shaping the volcanoes, escarpments, lakes and plains characteristic of East Africa. Like a raft tugging at its moorings, East Africa is itching to drift away from the rest of the continent and its efforts have torn a gash that runs 5 600 kilometres from the Red Sea to Mozambique. In central Africa this furrow divides into two branches – the eastern, bisecting Kenya and fringing the Serengeti, and the western, traced by a chain of deep lakes stretching from Uganda to Mozambique.

We motored up the escarpment behind a straining overlander truck and stopped to look down on Lake Manyara lapping at the base of the valley wall. The temperatures were dramatically cooler up here, and had us fishing out sweatshirts and beanies in a hurry. We had ascended into the Crater Highlands, a rash of volcanoes and calderas, of which the Ngorongoro Crater is most famous.

In 1951 Tanzania's colonial government proclaimed the Serengeti and Ngorongoro highlands a national park, evicting the Maasai and their cattle and upsetting colonial-native relations. It was around this time that Bernhard and Michael Grzimek, a father-and-son zoologist team, arrived both to study and film the wildlife of the park and to persuade the authorities against relinquishing a third of the Serengeti to appease the Maasai. In the end they failed: the Ngorongoro Crater and surrounds were excised from the park and downgraded to conservation area status, which meant the Maasai could continue to live and raise cattle there. Yet, through their films and books, the Grzimeks succeeded – some might say too well – in bringing a little-known spread of East African bush to worldwide attention.

Moses battled to find parking at the entrance gate to the Ngorongoro Crater. There were pop-up top minibuses and safari vehicles just like ours everywhere. Tourists thronged the reception and curio shop. A troop of baboons patrolled the car park, one of them leaping through an open car window to snatch an unattended apple, scaring the astonished occupant out of his socks and sandals.

Cyclist and truck, near Arusha.

Because the Ngorongoro Conservation Area (NCA) lies along the road to the Serengeti, a hefty US$30 per person entrance fee for the NCA must be paid, even by visitors in transit. Think of it as a toll fee. So, to get our money's worth, we stopped at a lookout spot to peer over into the crater. It's a magnificent sight, but our experience was ruined by the smoke-belching truck being repaired alongside, and the gang of sex-charged British teenagers who'd left their diesel bus idling on the roadside while they giggled and groped and photographed each other. Down in the crater itself there was an extraordinary amount of minibus traffic, clustered wherever there appeared to be herds of buffalo and elephant.

On the rim of the crater we passed the memorial stone where both Grzimeks are buried, the view from their gravesites partially obscured by a hideous hotel. A group of Maasai hovered nearby, dressed to the hilt, available for photo-shoots by tourists. We stopped for tea at a shamefully run-down camping area where crows and marabou storks cast sideways glances at our little picnic while they picked through garbage in the dustbins. Was it just me, or did this place suck?

The road deteriorated shortly afterwards into an obstacle course of loose rocks, corrugations and potholes. I expected our vehicle to shake itself apart any minute into a million little mechanical

Maasai herders, Makuyuni.

bits as it rattled and bumped at a snail's pace along the track. So much for the toll fee; the road was an insult to the hundreds of tourists bumbling along past us that day. Some clever-Dick drivers had abandoned this tortuous route and were speeding across the plains alongside the track. This meant that the landscape of the conservation area amounted to a bleak dust bowl; the little vegetation smothered in grey dust, the plains a maze of vehicle tracks, overgrazed by Maasai cattle and wild herds alike.

A humble sign in a grove of trees announced that we'd arrived in the Serengeti National Park. Protected from cattle and off-road drivers, there was an immediate and visible improvement to the scenery. Here were trees and long grass, and gazelles to eat it. And up ahead, plumes of dust, reminiscent of the Paris–Dakar Rally, where tour buses blazed a trail to the Serengeti's Naabi Hill entrance gate.

(Above)
An illustration of the ineluctable progress of globalisation, as a soft drink distribution truck passes a Maasai herdsman outside the town of Makuyuni.

Serengeti
BEING THERE

Bristle grass,
near Grumeti River.

A SCRAWNY, MANGE-RIDDLED CHEETAH HUNG BACK IN THE SCRUB WATCHING THE SCENE BELOW. HER swollen teats spoke of hungry cubs somewhere. There was a migration here of sorts, but the animals were not typical prey. They crowded the car park, pink and sweaty in crumpled safari outfits and Crocodile Dundee hats. They queued at the ablutions, grumbling about squat toilets. They carried video cameras and packed lunches that attracted flies and beggar starlings. They swatted the flies, shooed the birds and stamped their feet impatiently. The noise was deafening: a hundred vehicles left idling, coughing diesel fumes into the East African air. A bus stopped beside the cheetah – heads and cameras popped out of the roof. She withdrew deeper into the bush.

We hadn't expected to have the Serengeti all to ourselves, but the crowds at the Naabi Hill entrance gate came as a dismaying surprise. It was July, and the tourist migration was patently in full

(Opposite)
White-bellied bustard,
near Kirawira.

Getting there 19

swing. I wanted to turn my nose up at the chaperoned foreigners, but I was one of them. We'd all read the brochures and seen the documentaries: the drumming hooves, cunning predators, gnashing jaws of crocodiles and rivers of blood. We were all here for the live act: the annual drama of nearly two million herbivores on the move. And we had another thing in common: we'd all been relieved of yet another 50 bucks a day, plus camping and vehicle fees, for the privilege of coming really far to see what the earth looked like before we fixed it up.

Tanzania's famous national park covers close to 15 000 square kilometres, safeguarding the world's largest intact plains ecosystem. It is contiguous with other reserves and conservation areas, notably the Ngorongoro Conservation Area and Kenya's Masai Mara Game Reserve, which add another 10 000 square kilometres to the protected area. The grasslands feed and shelter an estimated 200 000 zebra, half a million gazelle and 50 000 topi. The rinderpest epidemic of the late 1800s wiped out 95 percent of the Serengeti's ruminants. But, since the eradication of the disease, the animals have bounced back. The migration's keystone species, the western white bearded wildebeest, now numbers around 1.2 million.

For the Serengeti's most celebrated herbivore, life begins in the new year, in the short grass plains near Naabi Hill. The herds assemble here between January and March to give birth to an astounding 8 000 new wildebeest *a day*. During this baby boom, 90 percent of the calves are dropped within a three-week peak period. The glut of newborn flesh quickly satiates the attendant predators – lion, hyena, leopard and cheetah – until the thought of wildebeest veal makes them want to throw up, which allows the surviving calves a chance at a lifetime of eating grass, walking around a whole lot and maybe getting lucky once a year with a like-minded wildebeest of the opposite sex.

There's magic in these short-stemmed grasslands. The shallow roots of grasses reach into soils saturated with windblown volcanic ash from the Ngorongoro highlands. These soils are packed with all the minerals necessary – calcium, potassium and sodium – to grow a new generation of wildebeest.

A layer of rock-hard calcium carbonate lies beneath the shallow surface layer, thwarting the penetrating roots of trees and bushes, so the landscape is appealing to anything with an appetite for lawn. But by April, these plains have all the prospects of a buffet table when the host has under-catered and you're last in the food queue. The herds feel a stirring in their veins, or is it a rumble in their tums? Time to pack the kids for the guided tour that fossil evidence suggests their ancestors have travelled for a million or more years. Hey, if you're destined to eat grass all your life, you might as well enjoy the delights of long-distance travel. The route, pre-programmed into their DNA and dictated by grass and water, points first west, then north, across the Grumeti River and on to the Masai Mara.

Wildebeest.
Musabi Plains.

The zebras lead the way, past smooth-bouldered kopjes and acacias browsed into umbrella-shaped topiary by giraffes, advancing towards the long-grass country. Here, higher rainfall and cotton soils support waves of red-oat grass, tall as a wildebeest's eye. The zebras have the technology – teeth and stomachs – to plough through the tall, rough stems, priming the fields for the wildebeest that follow. Wildebeest are more picky eaters, burdened with blunt muzzles designed to take big chomps out of short grass.

By the time we arrived, the herds had long since eaten their way through the short-grass plains. Heads down and teeth busy, they had mowed a trail northwest, beyond the yellow-barked acacias and shady sausage trees lining the watercourses of the Seronera Valley. Following westward-flowing rivers that drain into Lake Victoria, they had arrived in the wild and remote western corridor. This is where we were headed, to a special camp site near the Dutwa Plains, which we would share with a film crew documenting the Serengeti. They had asked Adrian to shoot images of the migration for the marketing of their movie.

Perhaps it's the romantic setting of woodland-fringed waterways, or just the abundance of food and water and close proximity of others that one day sets the animals' loins on fire. Suddenly 250 000 bulls begin to flex their muscles, check out the competition and ready themselves to romance 750 000 indifferent cows. The rut is on for three urgent, excitable weeks. Much like their human counterparts, the tsunami of hormones turns the bulls' voices thick and husky, and brings out some seriously peculiar behaviour.

We heard them before we saw them. We were looking for the turnoff to our camp, and were following a track that led west to the Dutwa Plains. Moses switched off the vehicle to listen for the drone of the filmmakers' generator. Instead we heard the guttural hum of a million bullfrogs emanating from a wetland just over a low hill. We crested the rise, but saw no marsh, no croaking amphibians – just 10 000 horny wildebeest. The plains had become a pick-up joint that boomed with the refrain of thousands of gnu getting to know each other:

'Who're you?'

'Sue. Who're you?'

'Paul. Who're you?'

'Sue.'

The sun was setting, and the low light shone through cream beards, glistened off Viking horns and highlighted dark corduroy coats. The animals grazed in tidy, single-file rows that sometimes moved in opposing directions, like dark trains passing slowly across the pale grasses. The rows seemed computer-generated, stacked all the way to the low, wooded hills that fringed the plain, their numbers beyond counting, like a *Star Wars* army.

Impala herd, near Kirawira.

There were also loose assemblies of females and calves that had been corralled into shifting strips of real estate, the boundaries only apparent to the male landlord and his rivals. The bulls patrolled the small herds, much like sergeants marshalling the troops, bellowing so stridently that I felt like I was standing too close to the speakers at a rock concert. 'Poor man's buffalo,' a friend had once called these monumentally comic creatures that looked to me like caricatures of themselves.

I'd never seen so many animals in one place. And this was just a drop in the migration ocean. I'm embarrassed to admit it, but I'd always imagined the migration to be a single unit of a million-plus wildebeest galloping across the grasslands in one big family. I realised then that the animals simply inundate the woodlands and plains, and move in a staggered procession over a course of weeks.

We found the tsetse flies first thing the next morning. Or rather, they found us. We picked them up as we moved through a grove of trees that harboured them. Funny, the guidebooks never mentioned that July in the Serengeti is a good time for tsetse fly enthusiasts – everyone else, pack a folded newspaper. They swarmed around the vehicle, keeping pace with us as we drove, then, one by one, began to find their way inside. We all spent the next hour studying the interior of the vehicle, as they snuck into the foot-wells to bite our feet, or ambushed us from behind to nip our shoulders. They seemed to concentrate in the front of the vehicle, where Moses and Adrian sat swatting them into the back. 'Hey, don't chase them here,' I complained, returning their serves in a spontaneous round of tsetse fly tennis.

They pestered us every single day we were there. My body was covered in swollen bumps, my right ear deformed like that of a rugby prop after a particularly stealthy assault. Eventually,

Zebra dustbathing,
Musabi Plains.

I seemed to spend more time on tsetse lookout than I did looking out of the window. On slow days, just to amuse myself, I wouldn't tell Adrian about the fly on his back, then ... wait for it ... yes! ... the obscenity and futile back slap.

Out on the Dutwa Plains the herds had doubled their numbers and were still filing out of the hills through stands of whistling thorn acacias. They bunched up at the shrinking puddles in roadside culverts, to drink the dregs from the last rains – the long rains that fall from March to June. A hamerkop was scolding the animals for muddying his waterhole, while wattled starlings flew in to perch on their backs. Bulls bashed heads, locked horns and stumbled through the shallows like tired boxers, while youngsters with nibs for horns chased each other in circles. Others just hung out. The open hatch of the safari vehicle was a bit of a novelty; standing up and sticking my head out for the 360 degree view, I joked with Adrian that I was seeing the Serengeti on foot.

A convoy of tour buses came past and set off a mini-stampede. The wildebeest coming down the hill headed back up; some fled the water, others ran towards it or ran in loose figure eights across the road and back again. 'Bewilderbeests,' the film technician had called them. Then, just as suddenly, they all settled down, the bulls wasting no time in re-establishing their harems.

Over lunch we swapped sightings with the film crew. Thirty thousand? That's nothing. You should see Musabi Plains. Billions of them, moving towards the Grumeti. They're gonna cross any day now. Man, how 'bout these tsetses?

'There's one on your arm,' I pointed out to the technician.

He explained that he was engaged in serious scientific research to determine whether the bite of a tsetse allowed to leisurely drink its fill doesn't burn and itch. The insect had been sucking on his arm for several minutes when it finally and heavily lifted off.

'Did it work?' We all wanted to know.

'No. Damn bite's killing me.'

Apparently the film wasn't going according to the producer's schedule – who can script the behaviour of two million single- and small-minded beasts? So far the technical team had crashed two

Suspension bridge,
Grumeti River.

model aircraft and just that morning had totalled a remote-controlled helicopter on its maiden flight, when it buzzed beyond the control range of the remote. So much for the aerial shots. Some of the crew had opted to spend the rest of the afternoon in the productive pursuit of toenail painting.

We returned to the Dutwa Plains one morning to feeble fires smouldering across the grasslands. The wildebeest had vanished and in their place superb starlings and marabou and white storks were catching grasshoppers fleeing the flames. I was confused as to how the fires had started. The grass was green, the skies were clear – there hadn't been any lightning. Was it poachers? A careless smoker? Or the park authorities themselves – was the entire migration artificially driven by man-made fires? And where had all the wildebeest gone? Had they crossed the Grumeti River, on their way to Kenya?

Frankly, I was getting a bit bored with croaking wildebeest. Let's face it, they're hardly the most arresting of God's creatures. We must have seen a hundred thousand of them during visits to Dutwa and Musabi plains, but not much else. There'd been scatterings of zebra, impala and topi, a pair of warthogs that lived in a burrow on the way to camp, a small and skittish breeding herd of elephant and a handful of buffalo bulls. I welcomed the opportunity to head to the shores of the fearsome Grumeti, where toothy trolls waited to ambush thirsty wildebeest.

Marabou stork,
Grumeti River.

By July, the Grumeti is nothing more than a festering trickle sucked impotent by the dry season. There were no wildebeest in the vicinity, but the crocodiles exceeded all expectations. There were three of them, all the size of petrol tankers, sunning on the banks, sleeping off the fat of last year's migration.

We crossed a bridge where a pod of hippo sulked in a fetid pool. A marabou stork perched in a dead tree on the other side, his crop swollen with stranded fish. Magnificent fig trees lined the banks, and a troop of olive baboons moved through their fat, smooth branches. Moses pointed out a bare-faced go-away bird and eastern grey plantain eater as we travelled beside the riverine forest on the northern shore. Then he stopped beside a skinny, dodgy-looking suspension bridge that was not for the faint-hearted or weak-kneed. I was balancing on it in mid-stream, five monstrous crocs playing dead beneath me, when I saw a flash of red and green in the treetops, which I'd like to believe was a narina trogon (still shamefully un-ticked in my bird book). But there was no way I was going to let go of the rails to confirm the sighting with binoculars.

The Grumeti crocodiles are renowned for being the biggest in Africa, the annual feast of wildebeest steaks sustaining their generous dimensions – some 6 metres in length and weighing up to a ton. As the roadside puddles dried out, the herds faced the daily challenge of drinking from the Grumeti's shrinking pools. In a matter of weeks the Grumeti would evaporate to sand and the herds could cross without so much as getting their itchy feet wet.

And, judging by the number of wildebeest on the northern shore, many of them had beaten the odds. We watched them mow their way north across the Ruwana Plains, restlessly keeping one step ahead of starvation. A long and challenging journey lay ahead of them. By September, they'd be trickling into Kenya's Masai Mara where they'd sit out the dry season. Then, come November, overcome by wanderlust, they'd be on the move again. Summoned by Serengeti rains and the stirring of unborn calves, they'd head south for Naabi Hill, arriving in the short-grass plains before the year was out. Apparently this is a better time to visit the Serengeti. The world and his wife are not nearly as interested in the February dropping of calves, allowing wilderness enthusiasts the rare opportunity to be alone at sightings.

I'm cautious of spitting on hallowed ground here, but frankly, take away the wildebeest and I'm not sure the Serengeti lives up to the hype. The aura of wilderness is wanting, largely on account

of all the hotels, tourists and traffic, with many operators showing a distinct ignorance of game-viewing etiquette. While the western corridor is considered wild and remote, with fewer lodges than Seronera, tourists here have been supplanted by something more menacing – transit traffic. The main game-viewing road in the western corridor doubles as a highway between Arusha and Mwanza on the edge of Lake Victoria. It's a mega-shortcut, and trucks, buses and regular sedans are not shy to use it at speed, driving over what's left of the Serengeti's wilderness spirit. Every day we saw squashed birds on the roads, and were frequently reminded that you take your life in your hands when stopping around a blind corner to watch wildlife.

Clearly, this scenario was not contemplated by the Grzimeks, whose lasting wish was expressed in the title of their film and book, *Serengeti Shall Not Die*. I'm afraid, guys, insofar as its wild spirit is concerned, the Serengeti may soon be roadkill. Or perhaps my expectations were just too high. I used to believe you hadn't earned your game-viewing honours unless you'd been to the Serengeti, but now I think it's become a bit of a cliché. I was forced to reconsider the southern African safaris I'd been so quick to put down. I'd had many more wild and intimate experiences there.

My dissatisfaction had nothing to do with our hosts, Wild Frontiers: Moses was a wonderful, intuitive guide, the camp staff were outstanding and even the filmmakers amusing. In the end I think the problem lay not only with the tourists and the trucks but also in being confined to a vehicle. For many Africa first-timers, the Serengeti, as viewed from the safety of a car window or roof hatch, probably lives up to all expectations. But, like all wilderness junkies, I felt like I'd graduated from Safari 101. I craved something more adventurous and intellectually stimulating.

It was time to see what else Africa had to offer. Time to stop the car and stretch our legs, to feel the earth underfoot and the sun on our backs, to pack Band-Aids and anti-inflammatories and experience the African wilderness *unplugged*, in 3D. Why not traipse the Bwindi rainforest in search of gorilla; snorkel the Okavango Delta and canoe the Zambezi River at the mercy of hippo and crocodile; get on our bellies with the beetles and lizards of the Namib Desert, then hike up Cape Town's famous Table Mountain, bend down and smell the fynbos?

Maybe, after that, we'd return to the Serengeti with a different perspective. In fact, we'd already been invited. On our last night the camp kitchen surprised us with a chocolate cake, and decorated it with the invitation, 'Welcome again Mr and Mrs Adrian, Wild Frontiers'. We wandered over to the kitchen tent to say thanks and farewell. The staff were sitting in rows on crates and upturned buckets staring at the tiny screen of the cameraman's laptop, watching *Gladiator* on DVD. When the chef saw us approaching, he raised a hand, smiled quickly and nodded, indicating he was happy we liked the cake, but he really didn't want to chat right now. Russell Crowe had just entered the Colosseum.

The curse of the Serengeti: officials seem to admit as many paying visitors as arrive, including innumerable tourist buses and heavily laden trucks that use the Park's roads as a short cut to Mwanza on the shores of Lake Victoria. As a result, quiet, contemplative moments are rare.

(Previous spread)
Massive flocks of queleas boil across the grasslands flanking the
Grumeti River, their feeding constantly interrupted by attacks
from predators such as this goshawk (bottom, centre).
(Above & Opposite)
This brown-veined white was attracted, along with countless other
butterflies, to the flowers of this Gutenbergia weed. Described as
'artful ambushers' by one authority, crab spiders lurk beneath the
flowers waiting to pounce on the unsuspecting butterflies.

(Previous spread)
The thundering hooves of a small portion of the Serengeti's 1.2 million migrating wildebeest kick up dust on the edge of the Musabi Plains.
(Opposite)
A couple of young wildebeest spar alongside a seep.
(Below)
The presence of water in this seep momentarily stalled the migrating herds on the southern side of the Grumeti River.

38 Serengeti

(Previous spread)
The clowns of the African wild - a wildebeest pronks at dawn.
(Above)
Fires - this one close to the Mbalageti River - constantly race across the plains' still-green grasses. They spur the reluctant herds to file onward and away from the flames.

(Above & Opposite)
The flames drive waves of insects before them. In the wild, the inevitable result is an influx of predators to the plenty. Storks and starlings patrol the edges of the fire, snapping up the fleeing bugs.

(Right)
A white stork lands to hunt along the edge of
the advancing flames.

Serengeti 43

forest

Bwindi
UGANDA

Bwindi
GETTING THERE

I WAS IN THE CENTRE OF THE WORLD, AND I LOOKED AND FELT TERRIFIC. I HAD JUST LOST HALF a percent of my body weight. A firmer, slimmer me – just like that. No starvation diet, no sweaty workout. My secret? The Equatorial Weight Loss Programme.

Everything weighs less on the equator, the captain explained, as he stopped the motorboat somewhere along the earth's midriff on Lake Victoria. We were returning from a visit to Ngamba Island Chimpanzee Sanctuary. The excitement of seeing chimpanzees in their patch of equatorial forest had sharpened my appetite and I'd assaulted the lunch buffet a little over-enthusiastically. And now, as the captain started up the engine, I could feel the kilos piling back on as we drifted into the northern hemisphere towards Entebbe, Uganda.

Mention Entebbe to anyone over the age of 30 and they are bound to recall the 1976 airline hijacking, the Jewish hostages and the Israeli paratroopers storming the airport. But this lingering association with violence does an injustice to this peaceful lakeside town, with its tropical green spaces and laid-back atmosphere. Entebbe today is much like it was when the eminent surgeon Sir Frederick Treves (1853–1923) visited in 1913, during its days as the administrative headquarters of the British protectorate. He considered it 'the prettiest and most charming town of the lake … the golf links are more conspicuous than the capital.'

(Previous spread)
Forest canopy.
Buhoma.
(Opposite)
Egrets & fishermen.
Lake Victoria.

Getting there 47

Medi Lwere, from Wild Frontiers, met us at the jetty and drove us past the conspicuous golf course to the nearby Sophie's Motel, a pleasant, family-run establishment in a quiet suburb. Sophie's must once have had a fantastic view of Africa's largest lake, a few hundred metres down the hill, but that vista had been snatched by a vulgar blue, multi-storeyed monument to arrogance and bad taste posing as a hotel on the lake shore.

Medi had recommended the Friday night buffet at the Windsor Lake Victoria Hotel down the road. In the mood for an evening stroll, we set off for the hotel on foot. In spite of the high walls surrounding many of the properties, suburban Entebbe felt safe and sleepy. Some homes were unfenced, with neatly tended gardens shaded by tropical trees in the front yard. One stately tree, the jackfruit, bore spiky, yellow-green fruits the size of rugby balls dangling from its stem. It's not the kind of tree under which you'd park your deckchair; the ripe fruit reeks of rotten onions and each one can weigh up to 20 kilograms.

The pestilence of lake flies that I had wished on the blue hotel found us instead, and we walked through clouds of them, waving our hands in front of our faces. It was perhaps this wild gesticulating that attracted the attention of the scooter taxi that drew up alongside us and revved eagerly. My instinct was to turn him away. What would my mother say? Me on the back of a motorbike, with no helmet, behind a strange man, in a foreign country? But in an unspoken instant, Adrian and I decided this could be a whole lot of fun.

These *boda boda* are one of the most common forms of transport in Uganda. They evolved from the bicycle taxis that ferried passengers, on seats above the back wheel, along the Uganda–Kenya border. The riders would solicit fares by shouting, 'border border', to pedestrians. Over the years, some taxis have become more passenger-friendly, with the added comforts of decorated cushions, and, in our case, a 100cc engine.

Bananas on tanker, Mbarara.

There is apparently no legal limit to the amount of passengers a *boda boda* can carry. Although I'm almost certain the manufacturer advises against lifting of any nature, judging by local practice Adrian and I could have squeezed onto the single backseat with space to spare for another grown man, a goat and two chickens. But then a second taxi arrived.

I climbed onto the back of the first and for an embarrassing moment didn't know what to do with my hands. In my brief history of motorbike riding I have always had some sort of romantic attachment with the fellow up front. Do I throw my arms around his waist like old times, or do I cling primly to his hips? I glanced over at Adrian astride the second scooter and saw his hands gripping something under the seat. Aha! Handles.

What an exhilarating way to travel: the wind in your hair, a sultry breeze in your face, a driver with a healthy regard for speed limits and other traffic. We arrived at the Windsor flushed and grinning and eager for the return trip.

At the hotel reception Adrian enquired in a mock-posh voice, 'I believe this establishment is serving a fine buffet this evening.' To which the lady replied, 'Well, there's a *braai* at the pool.' We found a table and asked the elderly, rotund waiter to recommend a good Ugandan beer. 'Ah, for you sir, a Nile Special,' he replied. Adrian had sampled a Nile already and considered it a little heavy as an aperitif. So he said he thought he might try the Bell Lager. 'No, that is beer for ladies,' he was reprimanded, 'Nile is man's beer, I'll bring you Nile.' So Adrian obediently sipped his Nile and shared my Bell, round after round. The beer and buffet were so delicious that I needed to schedule another appointment with the equator.

Medi collected us early the next morning and drove us through the world's scariest Saturday-morning traffic. The outskirts of Kampala were a snarling anarchy of overloaded *boda boda*, white minibus taxis, cargo trucks and killer buses – probably without a single roadworthy certificate between them. The keep-left rule was simply a guideline, and the potholed, disintegrating lanes an amorphous

Cellphone dealer, near Masaka.

free-for-all, happily accommodating three, maybe four, vehicles abreast, and not necessarily travelling in the same direction.

Drivers displayed a good-natured disregard for any road user smaller than themselves, and I was impressed how the *boda boda* passengers – often women in elegant dresses riding side-saddle – remained so composed as their kamikaze drivers swerved into the path of runaway juggernauts. Yet there was no indication of road rage, and everyone was restrained and forgiving. Hooters were blasted liberally and incessantly, but never in anger – they were merely audible versions of the indicator lights. Medi negotiated the chaos admirably, with concentration to spare for commentary on the sights and highlights.

Chickens and livestock wandered the congested unpaved 'pavements', where run-down shopfronts squatted beside shiny new ATMs. It was market day, and fresh carcasses hung from trees and rafters as open-air butchers plied their trade.

The traffic and urban chaos thinned out as we headed west towards Mpigi. I hauled out a map from under the seat and traced our journey to Buhoma, the small village that backed up against the Bwindi Impenetrable Forest. It was roughly 550 kilometres southwest of Kampala – a breeze, I thought. Six hours, tops. We should be there just after lunch. But I'd grossly underestimated the state of the roads ahead.

Uganda is home to roughly 28 million people, every one of whom seemed to live along the Kampala–Buhoma route. There was no such thing as the open road, no relief from people and bustling towns. Any village of any significance had a run of speed humps the size of Kilimanjaro along the main road. The shops lining the streets were typically windowless concrete blocks, with rows of fanlights above door level for ventilation. Buildings doubled as adverts for cellphones, paint and cosmetics, and were vividly painted in the yellows of MTN or the pastels of Sleeping Baby face cream.

The entrepreneurial energy of Ugandans is inexhaustible. There's nothing that can't be made, or caught, or grown, and then sold. Had we been in a shopping frame of mind we could have purchased bricks from Kajansi; traditional drums from Mpigi; corrugated iron implements and brightly painted stools a little further on; Nile perch near Lukaya; fried grasshoppers from children at Masaka, and a side of beef, fruit and vegetables and cellphone airtime just about anywhere.

The makeshift greengrocer stalls lining the roads were evidence of the country's fertile soils. The variety and bounty of fresh produce was astonishing. Colourful plastic bowls were piled with

Boda boda, near Entebbe.

Food vendors, Lukaya.

pyramids of shiny red tomatoes, buckets overflowed with potatoes that looked like parsnips. There were aubergines and lemons, pineapples and onions, and watermelons the colour and shape of giant gem squash. Medi stopped frequently, buying us mushrooms and mangoes and bananas to sample.

Ugandans are the world's leading consumers of bananas. Each year they harvest and eat some 11 million tonnes. No less than 50 varieties of bananas are grown, forming a major source of income for subsistence farmers. We frequently passed bicycles, wheelbarrows and pedestrians encumbered with entire branches – not just bunches – of the fruit.

We stopped for lunch in the modern university town of Mbarara. Shortly after leaving the town, the tar road ended. The landscape became more hilly, the dirt roads more potholed and brutal. After a couple of bone-shaking hours I found myself thinking that if it weren't for the hungry crush of humanity, we would have encountered rainforest long ago. Every scrap of the undulating countryside had been cleared for agriculture. By my calculations we weren't far from Bwindi, yet there was no end to the patchwork of tea and banana plantations that clung precariously to slopes and tripped down into gorges.

By now, we were crawling along narrow switchbacks, creeping around blind corners and cresting and descending gentle hills. Each time the view cleared I anticipated the great swathe of towering forest.

Vegetable vendor, near Kampala.

Instead, we'd roll into another lively village, with banks and cars and cellphone reception (there were signs advertising, 'MTN everywhere you go' – well, everywhere we went). Then more farms.

The children lifted my spirits, running alongside the road, or sitting in open doorways where lacy shawls hung. They'd grin and wave and shout '*Mzungu*! *Mzungu*!' with such fervour that it was as if we were the first tourists they'd ever seen. My enthusiasm for the return wave started flagging after nine hours.

Finally, 11 hours after we left Kampala, I saw our destination through a haze of fine mist: a scraggly wall of trees, bravely halting the onslaught of yet another plantation.

(Opposite)
Truck,
near Entebbe.

54 Bwindi

(Above)
On the outskirts of Buhoma village, farmers harvest tea leaves against the backdrop of Bwindi's forest canopy. The unfenced boundary between the park and the surrounding cultivated land is a stark and clearly visible divide.

Bwindi
BEING THERE

Moss,
along Muyanga River.

IN 1902, A GERMAN ARMY OFFICER, OSCAR VON BERINGE, WAS CLIMBING A VOLCANO IN THE eastern Congo when he came across a 'troupe of large black monkeys'. He promptly killed two of them, for the purpose of classification, and discovered a species new to science, the mountain gorilla (*Gorilla gorilla beringei*). Today, the rarest of the great apes bears the name of the first white man to shoot them on sight.

There are only an estimated 600 mountain gorilla left in the world, living in two isolated populations in the equatorial rainforests of East Africa. Uganda's tiny Bwindi Impenetrable National Park, just 331 square kilometres in area, harbours roughly half of the total remnant population. The rest live close by (but separated by a sea of farms), in the Virunga Mountains that straddle the border between Rwanda and the Democratic Republic of Congo (DRC).

(Opposite)
Great blue turaco,
Buhoma.

Situated on the edge of the Albertine Rift Valley, a portion of the western branch of the Great Rift, Bwindi ranges in altitude from 1 160 to 2 607 metres above sea level, uniquely encompassing both lowland and highland rainforest, which makes it one of the most biologically rich forests on the continent. Dating back over 25 000 years – before the end of the Pleistocene Ice Age – Bwindi has been a hard-working evolutionary incubator. Its current occupants bear healthy witness to this: 90 mammal species, including elephant and 11 types of primate; 350 bird species, of which nearly two dozen are endemic to the Albertine Rift; and at least 200 different butterflies, eight species of which flit only through Albertine Rift airspace.

Of the forest's major predators, leopard have gone the way of the dodo in recent times, but their place has been very ably filled by a six-legged killing machine with bulldog-like jaws. As if the very thought of this predator is so terrifying that it cannot be reduced to a single name, it is variously called safari, driver or fire ant – and many other less kindly labels. The insects march in flesh-eating swarms, devouring anything too slow to move out of their path. Studies comparing a patch of rainforest to an equivalent area of the Serengeti discovered that the ants consume more weight of prey than do the large savanna predators combined. Rumour has it that the ants can reduce an adult chimpanzee to a skeleton in a couple of hours.

Waterfall, Muyanga River.

Which might explain why, at eight o'clock one morning, the 18 tourists assembled on the lawn outside Bwindi park headquarters all had their trouser cuffs stuffed tightly into their socks. So what if we all looked like old-fashioned postmen; ain't no fire ants crawling up these pants legs.

Bwindi was established in 1991. Since 1992, the Uganda Wildlife Authority (UWA) has been coaching three of Bwindi's 23 gorilla groups on inter-primate social skills. And today, for the price of a month's groceries, a maximum of six humans can call on a gorilla family, in order to sit and stare at each other for exactly one hour a day. Thanks to a patient and sensitive habituation process, the silverback (the 160–200 kilogram head honcho, named for the grey hair on his saddle, which distinguishes him as an adult male) is not likely to tear you apart limb from limb the minute he lays his glowering eyes on you. Of course, if you forget your manners, he may charge and lunge at you, roaring like thunder and hammering the ground with his open palms, but chances are he's just bluffing. Simply stand your ground.

Dayflower,
Buhoma.

I looked around at my fellow trackers; would they stand their ground? Three garrulous Mexican women in their 40s and a thirty-something Canadian couple. Adrian had been allocated to another group of gorillas. The Canadians had shared lodgings with us at the Buhoma Homestead the night before, and they had a secret: they were actually American, but were too embarrassed by George Bush, and their countrymen who had re-elected him, to admit it.

Our young UWA guide, Moses (evidently a popular name in East Africa), pointed out a few other tips to surviving our meeting with the gorillas. Eating, drinking, smoking and flash photography were not permitted, and coughing and sneezing were to be suppressed, along with the painful shriek produced by accidentally sitting on a fire-ant nest. Like most Ugandans, Moses had a ready smile, spoke with an appealing singsong lilt, and pronounced gorillas as *goleeras*, frequently interchanging his r's and l's. We were told to keep a distance of at least four metres from the gorillas at all times. If a baby *goleera* should approach us we were not to touch it, because the silverback would be sure to ask us to refrain, 'and he does not speak English'.

The briefing over, Moses asked if any of us needed porters. Then he turned to the neatly dressed group (all in grey overalls with green gumboots) waiting to one side. He held up four fingers, and four porters approached us shyly. No haggling, no harassing. I chose Fred, a sturdy young teenager, to carry my hefty pack. Because it can take anything from 15 minutes to eight hours to find your allocated gorilla group, our hosts at Buhoma Homestead had not wanted me to go hungry, and so my rucksack was overflowing with several bottles of water and enough lunch for the Ugandan army.

We set off down a broad and damp grassy track running between two low, forested hills, all of us nervous and excited for our appointment with Mwirima, the silverback, and his dozen relatives, called the Rushegura group. A handful of trackers had left earlier that morning to try and locate the *goleeras* and make the going easier for us *toulists*.

On either side of us, trees marched up the hills. Anaemic trunks towered to the heavens, ending in a canopy of olive and lime greens. Fine clouds dusted the treetops and gathered in the canyons. It was a warm day, and the sun would soon burn off the mist. Still, this was a rainforest; if we were lucky we'd find the gorillas and get back to camp before the daily afternoon thunderstorm. With an annual rainfall averaging 1 500mm, Bwindi is an important catchment area for five major rivers all draining into Lake Albert.

The mist seemed to mute the sounds of the forest. I had been expecting a shrieking, Amazonian cacophony of birds and insects; yet, besides a group of chimpanzees pant-hooting in the dense upper storey close by, the forest was surprisingly peaceful. Streams giggled along the edge of the track, masked by a tangle of ferns and undergrowth where small birds flitted. Occasionally a great blue or purple-crested turaco would call out, but otherwise our little procession made the most noise. Moses' GPS beeped and his radio cackled with updates from the trackers, while the Mexican Señoras laughed and gabbled loudly in Spanish, peppering Moses with questions and anecdotes of their own.

As we walked, butterflies in shades of pale blue, purple and yellow danced around our boots, before settling on the droppings of forest duikers that had left their tracks in the mud. Splashes of black and white leapt through the under-storey as a troop of l'Hoest's monkeys came to spy on us. Their white Abe Lincoln-style beards looked stuck-on, and the red sheen on their backs glowed in the morning light.

'We can follow this track and visit the DRC, it's very close,' Moses teased. 'I will give you a gun and some *burrets*.' No, that's all right, we all agreed; the track was nice, but we'd rather see the gorillas. So we clawed through a small gap in the wall of vegetation on our left and emerged on a narrow, winding, muddy path that led uphill, deeper into the damp forest.

L'Hoest's monkey, near Kitahuriwa.

We had entered a three-dimensional riot of green, as if no other colour existed in nature. Things grew on top of things that grew on top of things, in multiple layers of ferns and mosses and creepers and lichens. Wanton vegetation devoured fallen logs, wrapped itself over slimy rocks and crept up tree trunks. I was nervous to stand still for too long, in case I was swallowed in this rampant organic march. The forest exhaled an earthy breath of soil and mulch and plants respiring. I could smell it growing.

We crossed a slippery log bridge over a mountain stream, then followed a path heading upstream. So far the going was easy, the cleared pathway and wooden bridges over gentle brooks were almost

park-like, and I wondered if I really needed the long-sleeved shirt or the gardening gloves I'd been warned to pack. We moved slowly and stopped regularly, the Señoras dawdling and posing for photo-shoots at a series of pretty waterfalls.

Fred and I struck up a conversation, which soon turned into a one-sided recital of his hardships. He had never travelled further than the next village, never been to Kampala, couldn't afford it. He was one of nine children; he had no electricity at home; he worked weekends at Bwindi to pay for his schooling; he cycled 24 kilometres to school every day. He hoped one day a kind *mzungu* would send him money to buy a scooter. Unfortunately for Fred I wasn't that *mzungu*.

As we began to move away from the stream, the uphill going got tougher, perilous even, as the forest closed in around us. I was feeling less mean-spirited towards Fred after he hoisted and pulled me over slippery rocks and fallen logs, often along steep, knife-edge contours. Once I lost momentum while scaling a particularly large boulder, and found myself being pushed, from the bum up, by one of the female porters. '*Asante*, thank you,' I panted. '*Karibu*, you're welcome,' she replied.

When one of the Señoras called for a toilet stop, I summoned Fred over and dug out my gardening gloves so that I could grope at prickly vines and branches for leverage. We stumbled on and I began to feel rather foolish, like some wilting English colonial, in floppy hat, tucked-in trousers and gloves, breathlessly panting '*asante*' to Fred, who responded each time with a sympathetic '*karibu*'. He charged a flat rate for his services, but each *asante–karibu* refrain increased the likelihood of him making that first-time trip to Kampala.

Sometime around midday, Moses' radio cackled with the message that the trackers had found the Rusheguras' last bedroom. Before gorillas settle in for the night, each adult builds itself a gorilla-sized bed on the ground from forest materials. Infants and juveniles share their mothers' nests. It is thought that these platforms prevent them slipping downhill while they sleep. Gorillas never use the same nests twice, probably because, as Moses explained frankly, they '*sheet*' in them during the night.

Gorillas are the most earthbound of all the apes and, youngsters aside, seldom climb trees. They typically roam less than one kilometre a day and very rarely more than two. This was good news for my aching toes as we left the slippery path and headed for the trail hacked out by the trackers.

Now we had to contend with tunnels of stinging nettles, tough vines that snagged and looped over our boots, tripping us up, and small bushes with tiny thorns that hooked our clothing. The Señoras had fallen silent, except to ask if we were close yet. Could they have a smoke break before the one-hour enforced abstinence in the presence of the gorillas?

After some time, Moses reported that the trackers could smell the gorillas. Then we passed a fresh turd on the path; I smiled at the thought that this was my first sign of a mountain

gorilla. Shortly afterwards we caught up with several trackers. They pointed to a shallow valley just ahead and Moses instructed us to leave everything but our cameras with the porters and trackers, who would remain there.

Then we moved down into the valley towards a small clearing. Moses stopped suddenly, turned back to us and said, 'So, who would like to see a *goleera*?' Then he pointed to a dark shadow, not five metres away, hunched up against a tree. I was startled by this sudden appearance and close proximity of what looked, through the puzzle of dense vegetation, to be an adult female. Would she take fright and flee, or charge? But she ignored us completely, and didn't so much as look up from the branch she was lazily stripping of leaves and placing in her mouth. She was blacker than midnight.

Gorilla trekking, near Ngiriisi.

A few steps on, two more females sat against the base of a tree, contentedly avoiding our stares with a bored, 'you again?' dismissal. The undergrowth around them had been trampled and tiny flies hovered over the flattened patches where other gorillas had lain. Black primate shapes shifted in the forest behind the females. Only the infants cared that they had visitors. Three hairy, teddy bear-like smudges frolicked with exaggerated, show-off actions in a sapling four metres in front of us. They wrestled up the stem, pushed and chewed each other, pretended to eat the leaves, turned somersaults in the branches, tumbled out of the tree, always checking out the visitors in a 'watch me!' kind of way. I was within arm's reach of one of them when Moses gently tugged on my arm. Of course: the four-metre rule, and the silverback that doesn't understand English.

There was a disturbance in the forest behind us and we all turned to see a youngster, the size of a chubby toddler, descending a tree. We stood between him and the rest of his family and he really didn't want to go the long way around. So he began to advance, self-consciously stiff-legged, rising up to beat a feeble, 'I walk straight, betta get outta my way,' very unconvincingly on his little chest. He lost his nerve when six pale faces just grinned back at him, and he trotted into the forest, giving us a wide berth.

A large silhouette moved through the trees. Moses cleared his throat and whispered, 'Mwirima! Silverback!' He was as huge as a barrel. His broad silver saddle and generous rump

Mountain gorilla, near Ngiriisi.

reminded me of a rhinoceros. As Mwirima slowly led his family out of the clearing, Moses continued to clear his throat gently, a polite, non-threatening gesture in gorilla society. The gorillas moved through the dense undergrowth with ease, before dissolving into shadows in a patch of something edible.

Our hour was up and our escorts began to move in the opposite direction to which we'd come. 'Shortcut,' they explained. They hacked a fresh path through the undergrowth, and then suddenly sped up. 'You must run, there are fire ants!' they shouted, and we all performed a spontaneous, hysterical hopscotch across a swarming patch of ground. While the Señoras squealed and slapped at their lower legs after we'd reached safety, I patted myself on the back for my nimble escape.

It was during this 'shortcut' that I realised just how impenetrable Bwindi was. The guides had decided that the quickest way down was directly down. Vertically down. A mud-slicked, 90-degree angle down. I also realised that, without any training whatsoever, and given an appropriately lubricated surface, a 35-year-old woman is able to perform the splits, survive and repeat the performance. Fred was a star. He walked ahead, held my hand and all but carried me down, acting as a very able backstop after every spectacular skid. In his cheap UWA-issue gumboots, he was far more sure-footed than I, but when he did slip he was quick to release my hand so as not to pull me downhill with him.

Eventually, it became impossible to descend upright, and after hunching and crabbing sideways for an hour, I engaged four-wheel-drive — went down on all fours, like a clumsy gorilla — grateful that my branch of the primate family tree had emigrated to the savanna. This is when I discovered the fire ant in my shirt.

Three knee-shaking, ankle-breaking hours later, we emerged onto the forest road and stumbled to the UWA headquarters for our graduation ceremony. Moses handed out gorilla-tracking certificates and the Señoras applauded, 'Bravo! Bravo!' as each name was called out. I tipped Fred the value of a year's school fees, and then limped into Buhoma village to meet Adrian. We sat at the Bwindi View Chalets and swapped tracking stories over Nile Specials. Men's beer.

(Previous spread)
The Ihihizo River flows through Bwindi's ferns and forest.
(Opposite)
The diminutive Muyanga River forms a slew of waterfalls on its way through the northwestern corner of the park.
(Above)
A spider begins the process of constructing a new web above the rushing waters.

(Above)
Apart from gorillas, one of Bwindi's main attractions is its more than 250 species of butterfly, with conglomerations like these around fresh dung and urine.
(Right)
A giant millipede - a specialist feeder on the forest's decomposing plant material - coils up in a defensive ball.
(Following spread)
Fire ant soldiers protect the entrance to their chamber. The ants can inflict a painful bite with their menacing jaws, which can reportedly be used as emergency sutures.

Bwindi 69

(Left & Above)
The white-bearded l'Hoest's monkey is one of the more common of Bwindi's 11 diurnal primate species. Although their foot structure is more suited to living on the forest floor, like all monkeys they readily climb trees to reach their favoured foods like the fruit in this individual's mouth.

(Right)
A young gorilla swings between saplings while the rest of its group sleeps. By the time we caught up with this group, it was deep in its midday siesta, a tranquil rest period after a morning's foraging.

Bwindi 75

(Above)
The sight of 160 kilograms of pure muscle that is a silverback mountain gorilla is truly intimidating. Fortunately, the animals in Bwindi's highly habituated groups are extremely relaxed, and silverbacks generally reserve any aggression for their male rivals.
(Opposite)
A smaller female forages in low-level saplings.

72 Bwindi

(Left)
The thick canopy and dense undergrowth help Bwindi live up to one of the interpretations of its name - 'place of darkness'. Even at midday, when this photograph was made, the gloomy conditions, and a ban on flash photography, push photographic technology to its limits.

wetland

Okavango
BOTSWANA

Okavango
GETTING THERE

IAN WAS HAVING SECOND THOUGHTS: 'BUT GUYS, IT'S GONNA BE FREEZING OUT THERE, AND I THINK I'm getting the flu,' he whined, standing in his Maun doorway in slippers. 'We should rather wait till September, when it's warmer … I've really got the winter blues.'

For as long as I can remember, the three of us had been planning to take a boat upstream into Botswana's Okavango Delta at the peak of the annual flood, when the waters trickle down past Ian's front door. Ian owned the boat and had an intimate knowledge of the delta's channels. He was our captain, our guide and our friend. It was that country's President's Day long weekend, we had stocked up on Old Brown Sherry and canned tuna – in case the fishing was lousy – and had driven 12 hours to get there; we were two determined campers. So we coaxed Ian – bullied, he might say – into loading up his boat with provisions for a four-night camping trip. I swear I saw a hot-water bottle peeking out of his bedroll.

An hour out of Maun the delta began to work its magic. '*Fishies*!' squealed Ian from behind the wheel. 'Guys, look … there … d'you see the fishies … there … under the boat! Baby tigers, I'm sure!' It transpired that Ian is something of a fish enthusiast, and before the end of the day he'd stripped down to shorts, donned snorkel and goggles and plunged into the freezing water to get a closer look at those *fishies*. When he finally emerged, shivering and beset by bloodsucking leeches, he was

(Previous spread)
Water lily,
Guma Lagoon.
(Opposite)
Warthog,
Kasane.

grinning through blue lips. This was not a man you'd readily associate with *stokies* and a hot water bottle. By the end of the trip we couldn't imagine a better way to experience the Okavango. Ian declared his winter blues healed, and so an annual ritual was conceived. But sadly, a year later, the plan was stillborn.

In the week before the long weekend, we were getting ready to go to Botswana again. Taking Ian's cue, Adrian had borrowed an underwater camera, and we'd invested in sets of goggles and snorkels to fully immerse ourselves in the delta. While we'd been tweaking our snorkelling skills in borrowed wet suits at home in the pool, Ian had gone shopping in Maun for a new tent and bucket shower.

We were loading the Blue Beast (our temperamental Land Cruiser) on the day of departure when we noticed that a slow and negligible oil leak had become a disturbing torrent and that the oil pressure gauge had gone on the blink. We called Ian, postponed the trip by a week and the AA towed the vehicle to the nearest Toyota service centre. Six days later we collected the Beast, remarkably unfixed considering the time it had spent with Toyota, and decided to drive it to a more reliable mechanic in Johannesburg. While looking for the leak, he discovered something far more serious – a cracked cylinder head – that would cost an arm and a leg and a good week to replace. After another call to Ian, we moved in with my sister, who happened to have the entire BBC series of Michael Palin's epic journeys on DVD.

Camp site.
Chief's Island.

Days passed, and we travelled vicariously with Michael to the Sahara, from the North to the South Pole and full circle across the Pacific Rim. The mechanic called from time to time to say he was waiting for some or other part from Toyota. After we'd gone around the world in 80 days, without moving from the couch, Adrian teased, 'Where'd you want to go to today? Mauritania? Bhutan?' 'Maun, Botswana,' I grumbled. The wait was unbearable. It had become a new occupation: we were

waiters. Finally, when we were at a horse fair somewhere in the Himalaya, the phone rang: the Beast was fixed and ready to go. If we timed it right we'd make the border with time to spare.

The journey was pretty uneventful until we stopped at Marnitz, literally a petrol pump of a town half an hour south of the border. Adrian gingerly opened the bonnet to check that no ugly surprises were scheming to ambush us. There was a hissing sound and a fine spray of cream-soda-green coolant spewed from the depths of the engine. This was perplexing, since we had just paid a mechanic the GDP of a small nation to tell us the Beast was 'good as new'. The radiator was completely empty. The proprietor contacted the only mechanic in a 30-kilometre radius, who fortunately happened to be heading that way, and would be there in 10 minutes.

We never got his last name, but the diminutive Johan-from-Marnitz performed intricate and speedy surgery on a carelessly punctured hose while standing on tiptoe on a beer crate, then refused to accept payment. We made the border with seconds to spare.

Since Botswana roadsides are mostly unfenced, stray livestock make for dangerous night driving, so we opted for a cold and sleepless night at a camp site on the shores of the Limpopo River, where truckers revved their engines and partied till dawn in the border parking lot.

Boy bathing.
Kasane.

We noticed the next day that the Beast overheated at speeds above 100 kilometres an hour so we spent most of the journey to Maun staring at the speedometer, temperature and oil gauges, while mopane woodlands, stripped leafless by winter, flashed past outside. We crossed dry riverbeds and passed improbably small villages, where the bus stop and 'bar–restaurant' were the most prominent features. Botswana is a wonderfully empty country, famously home to more cattle than its 1.7 million people, although I dare say donkeys are pushing for a close second. These slow-witted equines were everywhere and seemed to be particularly fond of standing obstinately in the path of a wildly hooting blue vehicle.

Along remote stretches, some villagers had set up temporary plastic shelters on the verges, where they slashed and collected bundles of yellow thatching grass for sale to passing traffic. We were waved through several boom gates, where veterinary fences bisect the roads and cut up the wilderness. The fences keep cattle and wildlife apart to prevent the spread of disease, safeguarding Botswana's thriving beef business. It was only after we crossed into the Makgadikgadi Pans National Park that we saw wildlife: ostrich and zebra, as well as a giant clay aardvark, big as a caravan, waiting to cross the road to the Kalahari Surf Club, a quirky lodge on the edge of the Pans.

Finally, we began to smell the wild sage that signalled the nearness of Maun. More bad news awaited us there. Ian had been called away on urgent business and would not be able to make the trip for another two weeks. A fortnight of tuna and cheap sherry loomed, though without the cheerful company of Michael Palin. But before the disappointment and frustration could bury us, our good friend Brent Dacomb of Travel Wild made a couple of calls. Next thing we knew, we were on the road to Nxamaseri Island Lodge.

We had last travelled this road during the dark days of a cattle lung disease outbreak, when every single cow in Botswana's northwestern Ngamiland district was shot, and a new grid of veterinary fences hurriedly erected. That was nearly a decade ago, and the area has since been restocked, with dire consequences for the surrounding vegetation. The landscape was now unrecognisable; where I remembered long grass and wildflowers, there was nothing but dust and anorexic cattle wandering aimlessly in search of grazing.

A few things remained unchanged, however, like the handwritten billboards advertising bus stops or grocery stores, the letters invariably trailing off the edge of the too-small board, and the buckets and tyres and bits of scrap metal hanging from the trees acting as signposts to villages obscured by the mopane tree line. The reed walls of the village huts hinted at the nearness of the Okavango, and the map confirmed we were driving along its shores, but in truth we were some miles from its flooded edge.

We turned down a track signposted by an orange bucket, then crossed a vast dry channel littered with elephant dung and spoor. After a few kilometres we stopped at the edge of an inundated flood plain, where tall, smiling Phuraki Ngoro greeted us from a small harbour of dugout canoes, called *mekoro* (singular = *mokoro*). He invited us to park the Blue Beast under a grove of fig and palm trees and offload our luggage. Then we boarded the humble craft that would transport us to a world far away from machines and mechanics.

(Opposite)
Palm trees.
Makgadikgadi Pans.

Okavango
BEING THERE

Dew on papyrus,
Nxamaseri.

BOTSWANA IS A FLAT, SUNBURNT, UNFORGIVING LAND, TWO-THIRDS OF ITS SURFACE SMOTHERED under a mantle of Kalahari sand. Yet, in the northwest of this arid country a giant 18 000-square-kilometre water hole sustains everything from forests to flowers, elephants to termites and hippos to tadpoles. This is the Okavango Delta, a glinting wonderland of flood plains, channels and islands, which might not exist at all were it not for the instability of our shifty planet.

The Okavango begins life in the southeastern highlands of Angola. Here, a dozen or so streams gurgle downhill and eventually join forces into a single narrow waterway, the Cubango River. Destined for the Indian Ocean, the Cubango struggles across Kalahari sands, advancing over the border into Namibia before entering Botswana as the Okavango River, in the region known as the Panhandle – a strip of land 95 kilometres long and 15 kilometres wide, shaped by ancient faults in the earth's crust.

(Opposite)
Reflected papyrus,
near Guma Lagoon.

Millions of years ago the Okavango River probably drained into the Zambezi, then into the Indian Ocean. But then Africa began to bump and grind with such enthusiasm that it tore a few muscles, creating the vast swellings and dimples of the Great Rift Valley. Scientists believe that weaknesses in the planet's crust extend beyond this East African rift system into Namibia and Botswana. Tectonic shifts (more bumping and grinding) in this system caused another chunk of the earth's crust to sink, moulding a trough that interrupted and captured the flow of the Okavango River. Over the ages the trough filled with windblown debris and sediment carried by the river, which shaped it into the gently sloping fan of the delta. These subterranean movements continue in the region today, and since the Kalahari is astoundingly flat (descending a paltry 61 metres over the delta's 250-kilometre spread) the slightest tectonic shift can cause the water to alter its course.

This permanent miracle of water in the desert promises even greater blessings each year, when afternoon thunderstorms two countries and nearly 2 000 kilometres away herald happy hour at the giant water hole. The Okavango's catchment lies in Angola, where summer rains set off a sluggish flood along the Cubango River that takes three months to reach the Panhandle and another four months to journey to the distal ends of the delta. The flood's timing couldn't be better.

Dawn, Guma Lagoon.

Angola's gentle wave arrives when the delta shores are in the stranglehold of the Kalahari's dry winter. The benevolent tide spills across the land, swelling channels, drenching flood plains and doubling the size of the wetland by resurrecting the dynamic seasonal delta, drawing droves of birds and animals to its shores. The Nxamaseri flood plain, which comes courtesy of these rains, is fed by the swollen Nxamaseri Channel, a wide, shallow waterway that veers westward from the Okavango River.

As Phuraki poled us out of the harbour, I realised that I had entered a realm where the wheel was completely useless, where carpenters triumphed over mechanics, where I could make speedy and steady progress with no more than two pieces of wood: a hollowed-out tree trunk and a sturdy branch (or *ngushi*) to pole it. Admittedly, Phuraki's *mokoro* was a luxury model, boasting bucket seats and fibreglass bodywork (an eco-friendly initiative to preserve the delta's mature trees), but, still, there was no bonnet beneath which any evil could lurk. Well, any mechanical evil, that is.

'If you see a crocodile, stay in the boat,' Phuraki warned, poised behind us, gondolier style. I had to wonder what kind of retard would jump out. But then I remembered the wet suits and snorkelling

Mokoro trail,
Chief's Island.

gear we'd optimistically brought along and decided that the flood plains certainly looked innocuous enough for a dip. The water was crystal clear, the colour of weak tea and thigh deep. A few weeks ago this was dry land – I noticed with some satisfaction that we were travelling over an immersed vehicle track. There'd be no pesky cars where we were heading.

Poling a *mokoro* is spectacularly difficult, yet Phuraki expertly shifted his weight from foot to foot to balance the boat, while he dug the pole into the riverbed to propel us forward, without so much as breaking a sweat. The *mokoro* sat low in the cool water, and I trailed my fingers beside it, cupping a handful of sweetness to my mouth. Tiny fish flashed silver through grasses that bowed under the strength of the current. It was midday, but the wintry sun was gentle, the journey serene and relaxing after the clamour of the Beast's diesel engine. The distant tinkling of donkey bells was unexpectedly pleasant and I began to doze off, all worries of radiators, gaskets and gauges floating away with each soft plunge of Phuraki's *ngushi*.

The far-off grunt of a hippo woke me and, surreptitiously wiping the drool from my chin, I noticed we'd drifted into the Nxamaseri Channel, hedged on either side by the tall stems of papyrus. Water lilies clustered in tranquil alcoves where pygmy geese paddled among the lily pads. The waters were deeper here, but just as clear, revealing a bed of detritus that glowed with the fiery colours of autumn.

We rounded a bend and came upon the lodge, tucked under a towering canopy of riverine forest. It was one of those wonderful old-style Botswana establishments, all whitewashed brick and thatch, which are now an endangered species in an era of pretentious, high-end luxury camps. Over a lunch of lasagne, home-baked bread and salad, Charl, the lodge manager, was upbeat about our snorkelling prospects. Did we have scuba gear? No? Pity. He knew an awesome pool in the channel just around the corner where he and a few mates had been diving just last week. Anyway, he would guide us up the river this afternoon, and some time during our stay we could look at a couple of snorkelling spots near the flood plains.

Late that afternoon we boarded a huge barge, the size of a squash court, and puttered slowly up the channel towards the Okavango River. All the wetland inhabitants seemed frantic to get through the day's chores before night fell. A pied kingfisher hovered a few metres above the water, eyes locked on his quarry, his head statue-still in spite of the furious fluttering of his wings. Suddenly he dive-bombed into the water, emerged almost instantly with a fish squirming in his pointy beak, and

flew off to the nearest tree to bash his meal senseless. I imagined him thinking, 'Okay, two more of these, then I can knock off for the day.' Little egrets and squacco herons patrolled the shallows, stabbing at the water as if challenging their reflections, occasionally squabbling over the same spoils. A pair of otters porpoised among the blue and white day lilies that were catching the last of the sun's rays before they closed shop to the beetles and bees doing their last-minute harvesting.

Water lily stamens. Guma Lagoon.

Soon the channel widened into the mouth of the Okavango River and we turned north, heading for a colony of whitefronted bee-eaters nesting in the exposed walls of the riverbank. Two dozen of the green-and-white birds fussed over holes in the cliff face, excavating and renovating their nurseries for the new batch of chicks. Research has shown that pairs mate for life, although God knows how you recognise your spouse in such a crowd. You could easily commit accidental adultery with the neighbour in the confusion of identical, closely packed burrows.

The waters of the river were deep, dark and restless, as if constantly looking for an outlet through the storey-high fence of papyrus that barricaded each bank. Despite appearances these green walls are not impermeable. Water seeps slowly through the reeds, filling secret backwaters, lagoons and oxbow lakes.

We stopped at a bend, tied the boat to a batch of papyrus and watched three African skimmers take off from a sandbank and lazily buzz the river, their lower beaks scraping the surface, snatching fish that had risen to the top for the evening. We toasted the sunset with ice-cold St Louis Lager, then motored slowly back to the channel.

As soon as the sun sank, yellow night lilies started their day and the skies were given over to bats and midges. Darkness came quickly. Charl plugged in a spotlight and offered it to Adrian and me to hold, but we weren't that naive. On a dark night, a million-candlepower beam is a magnet to every flying insect known to man – and a few more science has yet to meet. The dork holding the torch – usually an eager first-time safari-goer – is soon sitting with eyes and lips clenched tight, turning blue from the effort of not inhaling bugs through his nose.

Pangolin scales,
Selinda.

Charl shone the light into the shallow channel and the beam illuminated a world that anglers only dream of. The waters were literally swarming with the pale, ghostly shapes of fish. I recognised barbel by their whiskers, and Charl pointed out bottlenose and pike – each one large enough to feed a hungry family.

On the surface, crocodile eyes shone red, then sank beneath the water as the boat approached. Their movements were graceful and balletic – they turned doggy-paddle into an art form – but they were wary of this glaring, floating squash court trailing a swarm of insects. Snorkelling suddenly seemed less appealing after a croc of alarming dimensions demonstrated the powerful karate kick of his tail as he shimmied beyond reach of the beam.

The baby crocodiles that hugged the safety of the papyrus were far more cooperative. They were mesmerised by the light, like animals caught by car headlights, and allowed us to drift really close and examine them for as long as we liked.

As we headed back to the lodge, Charl shone the spotlight hopefully in the trees overhanging the water, looking for those nocturnal delta specials, Pel's fishing owl and the whitebacked night heron. We were out of luck, but the light did pick up a pair of green eyes belonging to a genet hunting on the edge of an island, as well as a line-up of five little bee-eaters huddled together against the cold on a papyrus stem.

'This is the scuba spot I was talking about,' said Charl, indicating a deep area in front of a narrow sandbank. 'Jeez, why here? What about the crocs?' I asked. 'Well, this was where the boat sank,' Charl explained sheepishly. As it turned out, the scuba dive was more of a salvage expedition after a belligerent hippo had upended one of the lodge boats. The passengers endured a wet and chilly, mosquito-plagued night on the tiny sandbank. Suddenly I had an urge to be back at the cosy, well-lit lodge – for more reasons than simply to see the insects in Charl's teeth.

In the early morning, after a long night's silence, all the residents of Nxamaseri soon had a lot to say. After a leopard cleared its throat with a series of gruff coughs, a Heuglin's robin opened the conversation with a controversial 'don't you do it', or words to that effect. It seemed the fish eagle

didn't agree with that sentiment at all and lodged a shrill objection. The jacanas and bitterns rasped and squawked that they had no opinion, really, either way. A pair of swamp boubou whistled and clicked, trying to change the subject, but a coucal bubbled its support for the robin, at which point several hippo guffawed derisively somewhere beyond the reeds. As the sun rose, so did the pitch of the argument, with doves, pygmy geese and crakes all adding their two cents' worth. The debate was clearly going nowhere, and it slowly petered out as the birds became preoccupied with the business of the day.

The diversity of birds in the channel was astounding – we ticked 14 species, including marsh harrier, malachite kingfisher and greenbacked heron, all in the space of half an hour and within two kilometres of the lodge. I was sure that after a couple of days we'd see a good proportion of the Delta's 400 recorded species.

Wetlands are the domain of those that can swim, float or fly – or walk on water, like the water striders we'd watched skating up to drowning insects and eating them. Gills, scales and feathers are a definite advantage, goggles and snorkels a humble substitute.

We had gone out en masse – well, in two boats with a handful of crocodile lookouts – for the much anticipated snorkelling session. We stopped at the point where the channel met the shallow flood plain. Now, perched on the edge of the boat in wet suit and goggles, the water no longer looked so innocuous. It was midday, but there was a chilly breeze. Mindful of the crocs, I let Adrian go first.

Local wisdom holds that crocodiles become lethargic in winter and would rather bask in the sun than waste their time on bony snorkellers. As I slipped into the channel, I realised the reptiles were onto something: the water was freezing. The delta's high rate of evaporation translates into a loss of heat from the surface, which means hypothermia will likely claim swimmers before a croc even bats a lazy eye.

I stalled alongside the boat for a few minutes while I waited for the water trapped in my suit to heat up, then stuck my head under water. It was deathly silent – beyond the din of my hyperventilation – and eerily murky, bathed in a muted yellowish light. The stems of water lilies created an underwater forest, where everything looked furry, coated in slime and algae. Bits of black detritus floated, suspended in the water, while a school of tiny silvery fish darted past, their eyes wide in apparent wonder at this goggled face. The underwater plants swayed in the current like practitioners of t'ai chi.

I couldn't shake the feeling that something was watching me from the darkness beyond my field of vision, and I moved slowly towards the shallower parts of the flood plain, where the drowned grasslands pricked my feet. I came up to see Adrian stalking a squacco heron that was fishing a metre or so ahead, completely unperturbed by this creature from the deep.

Back on the boat, wrapped in a towel and sipping sherry from the bottle, I was reminded of our last trip with Ian. There was something innately satisfying in collecting the wood to light the fire to cook the bream we'd caught, then heat the water we'd drawn, to fill the bucket shower hanging in the fig tree that shaded the camp from the afternoon sun (or, in Ian's case, to fill your sissy hot-water bottle when no one's looking). The delta had been our road, our pantry, our bath, its islands our home. Lion had roared every night, and a handful of bull elephant, faithful to their daily route, had trod within metres of our camp site without paying us a moment's attention. I was desperate to do it all again and I knew that one day soon we would.

Adrian emerged in time to startle a *mokoro*-load of fishermen tending the nets they had strung across a narrow side channel. They regarded us with bemusement, and I returned their gaze with envy. I was aware that with all the luxuries of the industrialized world at my fingertips, it was facile to covet the lifestyle of these villagers. But I really didn't want to go home. What if we stayed here for good? We just needed a month or so, I calculated, to turn a tree into a *mokoro*, and the same again to learn how to pole it. Adrian could build us a house of reeds and thatch, we could live off water lilies and fish – which I could catch with a spotlight if I had to.

Island and channel, Nxamaseri.

But, after a couple more days, Charl said we had to go. Something about needing the room for incoming guests. He had arranged for a *mokoro* to take us back to the Land of Land. Could we trouble him for just another month or two? No? He was polite, but unmoved: the boat was waiting for us. And so was the Blue Beast.

(Previous spread)
A pair of elephants trudge across a flood plain near Zibalianja Lagoon after their daily drink.
(Right)
A female leopard on a fallen log, Selinda.

102 Okavango

(Previous spread)
A little egret stands alert amongst a maze of reeds in a Panhandle backwater.
(Left)
One of the most widely distributed of the world's birds, a moorhen forages alongside a lily in the Nxamaseri Channel.

(Above)
Greenbacked herons are a common sight along the edges of the Okavango's waterways - standing motionless before suddenly darting forward to catch their prey. Here, one takes flight at the approach of our mokoro.
(Opposite)
The Okavango is a breeding ground for the locally endangered African skimmer. The bird's nesting sites - exposed sandbanks - are threatened by dam building and other disturbances like motorboat traffic, whose wakes flood the nests.

(Right)
The call of the African fish eagle is synonymous with Okavango days. Moments before impact with an unsuspecting fish, an eagle flares its wings over the Nxamaseri Channel.

(Previous spread)
A spray of diamonds accompanies a darter's
lift-off from the banks of a narrow channel
feeding into the Guma Lagoon.
(Left)
Thousands of Nile crocodile were hunted
in the Okavango Panhandle in the 1950s and
1960s to meet a demand for their skins in
the fashion trade. This individual, though
still wary, has less reason to fear humans.

desert

Namib
NAMIBIA

Namib

GETTING THERE

W E WERE CHATTING TO A YOUNG BRITISH JOURNALIST AND HIS JAPANESE WIFE, AT DÉLICES DE France, an outdoor French café, in a Germanic city, on the southwest coast of Africa. Little wonder I was feeling disorientated. I was in Windhoek, I kept reminding myself, just a two-hour flight – in business class, courtesy of a fortuitous Air Namibia upgrade – from Johannesburg.

The journalist was having a bit of trouble at work. It seemed that wherever he went to cover a story – London, Indonesia, the Caprivi Strip – some act of God or terror would erupt shortly after he left. Bomb blasts, floods and fires had dogged his travels around the world. We asked if he had any stories in the pipeline on the Namib Desert. No, he assured us, he was off to Katima Mulilo the next day to report on a school that had burnt down after his last visit. We'd be safe.

The twice-weekly flight to the remote Wilderness Safaris' Skeleton Coast Camp departed early next morning. There were eight of us on board the 12-seater Cessna Caravan. We were eager to make friends, since we'd be spending the next five days in each other's company in the desolate north-western reaches of Namibia.

Windhoek quickly disappeared from view, swallowed up by the hills surrounding it. Below us stretched a bare, faded landscape in mottled shades of pale green and brown, peppered with scrub. Dark bushes outlined the long-dry meanderings of fickle rivers. The occasional dwelling looked

(Previous spread)
Gemsbok,
near Khumib River.
(Opposite)
Windblown sand and tracks,
near Sarusas.

Getting there 115

fragile, tenuous and a long drive from everywhere, on blinding-white tracks. How did those rugged sheep and cattle farmers manage?

The terrain soon became increasingly inhospitable. It was as if every conceivable natural disaster – flood, fire, earthquake – had ravaged the area. Perhaps our journalist friend had passed through?

The further we travelled, the more pummelled and bruised the earth appeared, until it was drained of all colour, just an unrelenting dull beige. Then, low, dark mounds rose in the distance like scabs. Close-up, they resembled mine dumps, their flat tops heavily weathered and flayed by wind. These granite outcrops were slowly breaking down into their component minerals, dusting the surrounding plains with the reds of feldspar and greys of mica.

The bleak expanse below was completely alien, yet strangely familiar – like photographs of Mars – nothing but craters, sand and rocks, and now also the tyre treads of *Spirit* and *Opportunity*, the solar-powered robot explorers. There were tracks on the desert floor too, the organic squiggles of tired hooves in search of water, and the rare linear blaze of a road that went nowhere. I felt more at home, 2 000 metres up in the sky, in what I had come to think of as the Starship *Enterprise*, than I would have down there. The view made me thirsty.

Barchan dunes, near Breaker Bay.

One of our companions, Alain, a quick-witted Frenchman, was rummaging in the cooler box at the back of the plane. 'Er, *shiecken* or *bief*?' he grinned as he squeezed down the aisle handing out bottled water to the rest of us.

Volcanic massifs appeared as we flew over the home of the hardy Damara people and the rare desert elephants. I had travelled this way by car several years back and remembered the steep ravines, the skeletons of rivers, the villagers who sold rocks – their only crop – to passing traffic.

Hours passed. We were flying over yet another ghostly watercourse, the Hoarusib River, following its parched trail to the coast, when an unusual colour caught my eye. Green. There

was a patch of life – a reed-and-grass-frilled spring at a bend in the riverbed. Water! An oasis. My eyes searched the spot, hungry for a sign of another living creature. Perhaps the others also felt this loneliness of spirit. The pilot flew low over the next dark pool and everyone craned against the windows. But nothing stirred.

Finally, the granite contortions gave way to vast plains, then to folds of sand dunes, powder-soft and blushing pink. It was a daunting emptiness shaped by wind. Sand, blown against small shrubs, had accumulated into low humps, while fields of crescent-shaped barchan dunes migrated across the desert in an effort to escape the prevailing gales. I gave up the search for life; nothing could possibly survive in such a wind-scoured wasteland. I wondered if the others shared my sudden apprehension. Whose dumb idea was it to come *here*?

And then we came to more water: an unlimited, yet uninviting, supply of icy Atlantic Ocean that battered the pale coastline. These were the seas that have mocked human endeavour for centuries, wrecking and beaching ships and dooming survivors to a sunburnt, thirst-crazed death. Early Portuguese sailors called it *As Areias do Inferno* – 'the Sands of Hell', which is just another way of saying, 'the Skeleton Coast'.

Atlantic Ocean, Skeleton Coast.

Having convinced his cargo of their questionable taste in travel destinations, the pilot nosed the plane back inland and began the descent. A few minutes later, somewhere between desert and sea, and distressingly far from everywhere else, we touched down – or rather bounced, then skipped, along a soft sand airstrip. A small, tented encampment flashed by the window. Nestled in a valley, on the shores of a dry river, it looked cheerful yet vulnerable, like the desert could unexpectedly devour it.

'Welcome to Hell,' greeted Linus Hanabeb. He didn't look like Satan. In fact, he seemed, to my significant relief, to be a fellow earthling.

Namib
BEING THERE

Namib sand,
near Khumib River.

Hell, Mars, Namib Desert, same thing. As it turned out, the place was crawling with alien life forms. Over a lunch of gemsbok stroganoff, I learnt that we had arrived in a post-apocalyptic, science-fiction world where lizards have spades for noses, beetles do handstands, hyenas eat fruit and safari vehicles come equipped with brooms. With an endemic species list as long as my arm, it was as if God had handed over the reins to George Lucas when the time came to create the Namib.

The Namib Desert burns a dusty 2 100-kilometre trail along Africa's southwest coast, from the Olifants River mouth near Lambert's Bay in the Western Cape, to San Nicolau in southern Angola. It's been around for 55 million years, making it one of the world's oldest deserts, and is characterised by gravel plains, shifting dunes, granite outcrops and sun-dried watercourses. Roughly one and a half million hectares of its Namibian spread are given over to the Skeleton Coast National Park.

(Previous spread)
Cessna Caravan,
Kaokoveld.
(Opposite)
Gemsbok horn,
near Salsola Plains.

Dunes,
near Sarusas.

'Dress like an onion – in layers,' Linus advised, before we set off in the afternoon for an outdoor lesson on what makes these badlands tick; the gravel plains would serve as our classroom. It was a balmy summer's day in the desert, yet we carried bundles of fleeces, jackets and beanies in preparation for the coastal winds that can cause temperatures to plummet in minutes.

Because of the vastness of the Namib and the unfriendly weather conditions, we were forced to make a concession on our 'unplugged' resolution. We would have to get back into a car, in this case a spacious, *closed* safari vehicle. But Linus assured us that we could hop out and walk whenever the mood took us. We would be keeping to the limited road network in the park, since the desert plains are easily scarred by vehicle tracks, and take decades to heal. Should we need to turn around on the narrow, single-lane roads, a bit of housekeeping might be called for, which is why a sturdy garden broom is perched above the hi-lift jack on the front bull-bar.

As well as being very old, the Namib is also one of the driest deserts on our planet, with a mean annual rainfall ranging from just 5mm in the west to around 85mm along the eastern edge. Mean indeed. It wouldn't much matter if it never rained at all, because every other night the wet season arrives regardless. Precipitation takes the form of a nourishing mist that creeps in after sunset and

burns off by mid-morning, sustaining a cornucopia of mammals, birds and creepy-crawlies. It all starts far out to sea, where warm moist air from the open Atlantic is cooled as it blows over the frigid Benguela Current sweeping up from Antarctica. These air masses drift on shore and collide with the dry heat of the desert, resulting in a bank of condensation that rolls as far as 100 kilometres inland.

Not far out of camp I noticed a greenish tinge covering the desert floor up ahead. Whatever it was, it had mirage-like qualities; we were unable to gain on it, until Linus stopped the vehicle and invited us to get out and examine the ground. Black shrivelled plants lay all around. 'Look, it's lichen!' he exclaimed. Linus was clearly in awe of the desert ecosystem, summing up each disclosure as 'amazing', which he pronounced with a mixed Damara-Afrikaans accent, drawing out the second 'a' – as in *amayzing*. He plucked a small plant from the ground, poured a drop of bottled water on it and told us to watch and wait. The plant began to unfurl and slowly turn a shade of green. We were standing in a field of foliose lichen, the Namib's answer to the Serengeti grasslands.

I learnt that day that lichen is neither plant nor animal, but rather a marriage of algae and fungi that together live a long and successful life under trying conditions. The fungi is the breadwinner, providing stability and support by way of roots, drawing nutrients from the soil and absorbing moisture from the fog to prevent the algae drying out. The algae is the homemaker, using the ingredients of water, light and carbon dioxide to photosynthesise sugar and starch for carbohydrate energy. These Namib lichens stabilise the bare soils and provide an important source of food for springbok. '*Amayzing*, hey?'

Back in the vehicle, a few hundred metres down the road, we finally saw something familiar. A family of suricate mongoose interrupted their foraging for invertebrates (from which they derive all the moisture they need) to stand on their hind legs and stare at us as if *we* were from Mars. When one of them gave the subsonic order to scram, they disappeared into burrows and the plains were empty again. But not for long. Soon we were on a roll, spotting springbok, ostrich and gemsbok, all co-operating to make the Namib appear a little less unfriendly. Each species has carved an evolutionary niche for itself, and the animals obtain their moisture from dew and whatever leaves, grasses and succulents they can scavenge.

We followed the dry Khumib River course back to camp and came across seven giraffe feeding on the stunted trees on the banks. 'So, you live in the Lowveld, eh? You must know this tree,' Linus said, stopping the vehicle beside a grotesquely deformed shrub. 'Tree?' Adrian and I looked at each other; to call this a tree was a huge exaggeration. We'd never seen anything like it in our lives. 'Adrian's the tree guy,' I said, shirking responsibility. But Linus wouldn't let me off the hook. I pretended to study the leaves, they looked combretum-like, but I wasn't going to make a fool of myself and say 'leadwood'. This bonsai eyesore patently bore no resemblance to that tall, handsome bushveld

giant. 'Um … leadwood?' Adrian guessed. And before I could point out, by way of a loud guffaw, what a dimwit my husband was, Linus exclaimed, 'Yes! Isn't it *amayzing*? It's the *omumborumbonga*, the holy tree of the Herero people. It grows like this in the desert, because of the wind.'

Aha, the wind. I was suddenly grateful for the closed vehicle when the chief architect of the Namib decided to pay us a visit. It was a fully clothed onion that emerged from the game-drive vehicle at the end of the day, downed two glasses of welcome-sherry and made for the cosy candlelit embrace of the main lodge.

Stunted mopane, Khumib River.

The wind howled every night after that, whipping at the tent walls and thumping the wooden deck. But, while I tossed and turned under the covers each night, something extraordinary was happening outside. Breakfast was being prepared for the lizards, spiders and beetles resident in the dunes. The crumbs of the desert – wind-blown detritus – were piling up against the leeward side of the dunes, known as the slipface. At first light each morning we hoped to see the denizens of the sands emerge to feast on a granola of seeds, beetle larvae, sloughed-off animal bits and fragments of plant matter. Then, if we were patient and the conditions were right, we might also be audience to beetles performing handstands.

First we had to find our way out of the tent in the thick fog, which was so dense we could barely see three metres in any direction. We usually located Linus and the vehicle by the dim glow of the headlights; then we'd set off for the dunes. One morning, after staring at the whitewashed view out of closed windows for some time, Linus stopped beside what looked like a pod of hippos basking in the mist. 'Porcupines like to sleep in these rocks,' he said. 'Should we see if we can find one?'

Adrian spotted the clawed, five-toed tracks leading away from the rocks and across the gravel plains, disappearing into the fog. After following the trail for a few metres I looked back over my shoulder into a featureless murk; the fog had swallowed the car and the rocks. Now I faced a small dilemma: do I tread lightly like a good conservationist, or stomp a deep, long-lasting trail that I could follow back to the car if Adrian and Linus both suddenly kicked the bucket?

Tenebrionid beetle,
Skeleton Coast.

We had been trudging – one of us more heavily than others – through the fog blanket, staring at the ground, for about ten minutes when Linus stopped and pointed to a spiky bush. As my eyes focused through the mist, I realised it was a porcupine, standing motionless to escape detection. He froze for a few seconds before turning and lumbering off at speed into the fog. We followed his tracks across the plains, into a dip and up a rise, down a river valley and along the riverbed, until our hair and clothes were wet from the condensation, but we never could catch up with him again. 'Porcupines can run very fast when they want to,' said Linus. 'It's *amayzing*.'

Afterwards the fog lifted slightly and the wind picked up. We chose a suitable-looking dune, and then patrolled the base for detritus-munching life forms. Nothing. We struggled up the quicksand on the windward side to the dune crest – three steps up, one plunge back – sending waves of sand flowing downhill. Then we lay on our stomachs and peered over the crest down the slipface, careful not to disturb the loose sand on that side. 'There's one!' I exclaimed, pointing to a black beetle the size of a five-rand coin staggering up the dune.

The drinking habits of some of the Namib's tenebrionid beetles (of which the desert supports 200 species) have been fascinating scientists and filmmakers for decades. On foggy mornings, the little Volkswagen-shaped bugs lumber up the dune slipfaces until they reach the crest; then they lower their heads and tip their bums into the air and wait. The fog condenses on their hind legs and slides down their rounded carapaces, before flowing into their waiting mouths. Okay, so it's not quite the stuff of Olympic gymnasts, but it's a helluva way to swallow over 30 percent of your body weight in a single morning.

Our solo act was taking some time getting to the top of the dune, and on closer inspection we realised why. He had only five legs and was missing a feeler. He didn't look like he was up to morning acrobatics, and since the fog would most certainly evaporate before he summited we went off in search of the next rung of the food chain – shovel-snouted lizards.

Eating beetles and drinking fog, the Namib's *Aporosaura* lizards also live in the dune slipfaces. Their duck-beak noses look as though they've been clubbed with a spade, and I like to think this

is how they got their name. But Linus explained that actually their snouts are shovel-shaped, an adaptation which streamlines their speedy retreat into the sand to escape predators such as the side-winding Peringuey's adder.

The wind had cleared all but the freshest hieroglyphic scribbles left by the reptiles during their investigations of the detritus buffet. Linus traced their journey with a finger, knelt down and plunged both arms gently into the dune. Then he slowly raised his hands, sifting the sand through his fingers. Typically, when he does this for other guests a startled lizard appears cradled in his palms, but on this day the lizards had all vanished.

Linus tried again after lunch, and it was late in the afternoon when he lifted his arms out and giggled, 'I've got something. Let's hope it's not an adder.' The sands fell away, until in his hands lay a delicate lizard, the pastel colours of coral with a black leopard-print pattern across its back. It was dead still. Linus lowered it onto the dune for Adrian to photograph; I blinked, and it vanished, in three rapid, wriggle-swim moves that reminded me of a 1960s dance style.

Shovel-snouted lizard, Sarusas Spring.

Oh look, more sand. I began to feel dejected during the drive back to camp. The skies were overcast, an icy wind was howling and there was sand in my ears, my hair, my pockets and in the cameras. We had separated from the group in order to photograph beetles and lizards for the day. And had failed. But there was something else driving my mood, an overwhelming loneliness that transcends the comfort you receive from a spouse or kindly host. Adrian felt it, too. 'It's this place,' he concluded, 'humans are not supposed to be here.' Travel writer Brian Jackman once wrote, 'All my life I have loved wilderness and wild places, but the Namib's unrelenting hostility defeated me.' That was precisely how I felt. Beaten, conquered by wildness. Back at camp, a gust of wind blew over the tray of welcome-sherry, and when we bumped into Alain he wanted to know, 'you find good *bettles*?'

Perhaps Linus sensed our depression, because he had a treat for us the next day. We drove south for a couple of hours through the fog-shrouded plains, then emerged at a lookout that Linus assured us had a spectacular view. We drank coffee and devoured home-made muffins while waiting for the mist to clear. It didn't, but we were able to make out a river valley below, into which we descended. At some point we rounded a corner and saw a distant pond, shimmering through dense vegetation, at the bottom of a black-faced canyon. 'That's where we're headed, to the Hoarusib River Canyon,' Linus explained.

A few kilometres on we came to a tall, fat *albida* at the entrance track to the canyon. My spirits soared at the sight of this single robust tree. After several vegetation-starved days in the desert, this was the most beautiful specimen I'd ever seen. Bearded moss weighed down its branches and birds twittered in the spreading crown, tending their nests. The sun came out and I thought, 'Could this get any better?' I was back home, on earth, where there were trees and birds and springs – and shelter from the wind. Wild tamarisk hedges lined the track, a flock of Egyptian geese passed overhead and, wait a minute … are those lion footprints?

We followed the pug-marks of three lionesses into the canyon and stopped in a muddy, grass-covered parkland. Springs and streams sparkled beneath the granite walls; a Cape cormorant fished in a mossy pool, while a grey heron perched in the crags and watched us. Even the gemsbok carcass (the work of the lions?) did little to dampen my mood – what an idyllic final resting place. Elephants had been here too, their football-sized droppings remaining as evidence of their visit.

The Hoarusib is one of the Namib's ephemeral rivers, typically only flowing after exceptional rains fall inland. It drains westward into the Atlantic, and we followed its spring-dotted course to the beach. Palm trees lined the banks. The temperature dropped and the wind picked up as we neared the river mouth, causing sheets of sand to cascade off the granite walls like waterfalls.

We came out onto the beach, where herds of gemsbok and springbok drank from a freshwater pool. And then we ran out of petrol. A faulty fuel gauge had tricked Linus into believing he had a fuller tank. He radioed for backup, then manoeuvred the car into a windbreak position and unloaded deckchairs and lunch. We picnicked in the warm sun, while gulls called overhead and angry green breakers crashed on the beach. The waves mesmerised me until I drifted off, surrounded by the smells and sounds of childhood holidays at the seaside.

I was woken by the arrival of the Land Rover bringing fuel. Two young men jumped out, and while Linus and the driver refuelled our vehicle the passenger ran down to the numbing-cold sea and stared at it for some time. Then he looked back with a grin, to make sure his services weren't needed, before wading in up to his knees and splashing in the water. He scooped up a handful of salt

water, tasted it and threw it away, laughing. His actions suggested such unrestrained, childlike wonder that it occurred to me he had never seen the sea before. He dragged himself away, walked towards me and sighed, 'Ah ... the sea.' At that moment, a ghost crab ran down the beach towards the tide; he ran after it at speed, but the crab escaped. Then the sea hypnotised him again for a long while, before the driver called out that it was time to go.

Kelp gulls, Cape Frio.

'*Ai*, Himbas,' chuckled Linus after they'd left. It transpired that the young man belonged to the desert-dwelling tribe for whom water is like gold. For someone who has likely rarely taken a bath – for sheer lack of the sole ingredient – the sight of the ocean must be dizzying. I remembered my sullenness the day before and couldn't imagine a Himba lifetime of Namib wind and sand.

The tide was out, and we drove along the coastal graveyard of whales and ships and men. We passed the tracks of jackals and brown hyenas that, together with the ghost crabs, are the undertakers of the Skeleton Coast, cleaning the beach of the dead and dying. But what of the man-made litter vomited by the sea onto the shore each day? Tons of plastic, rubber, glass, fishing nets and buoys, washing machines and general consumer bric-a-brac marked the tide line. Why didn't the park authorities clean this up? Maybe they did, but the magnitude of the flotsam overwhelmed their efforts.

Further up the coast a huge seal colony was engaged in doubling its size. Namibia's nutrient-rich Benguela waters sustain around one million Cape fur seals, two-thirds of the world population. From late November, seal mothers give birth to a single blue-eyed, black pup, bearing an astonishing resemblance to a Labrador puppy. Something about the 20 000-strong colony reminded me of the wildebeest herds of the Serengeti. Perhaps it was the simple massing of animals, or the lowing and roaring of adult bulls defending their territories, hoisting and flinging their blubber-swollen bodies at rivals, like clumsy sumo wrestlers.

There were newborn pups everywhere, bleating like lambs for their mothers' attention. We watched a female give birth, arching her tail, shifting around and straining for several minutes until a

Ghost crabs.
Cape Frio.

slimy black lump plopped out. She turned to investigate it, sniffed and called to it, then clasped it in her mouth and dragged it through the sand none too gently, dropping it beside her. Within 10 minutes the newborn was suckling.

Kelp gulls and pied crows moved in quickly to dispose of the afterbirth, and mangy black-backed jackals patrolled the fringes looking for dead and dying pups. I realised then that the sand-covered mounds I'd been tripping over were dead seals in various stages of decomposition, and I was grateful for the chilly sea breeze that carried away the stench of birth and death and dung. There were hyena tracks too; I thought of their unfortunate inland cousins, subsisting on a diet of !Nara melons while these coastal dwellers could not keep pace with the glut of fresh meat.

Our seaside outing had left us refreshed and invigorated. Tomorrow we'd have another bash at the beetles and lizards. Back in the cosy dining room we swapped travel tips and anecdotes with the rest of the group over pork fillet, preceded by avocado, salmon and asparagus starters (and followed by granadilla cheesecake). When we stood and excused ourselves for the night, Alain called after us, 'Don't drem of bettles!'

On my last day in the Namib, I wandered down the riverbed and sat in the shelter of a salt bush to soak up the desert silence. The only fly in a 10-kilometre radius found me and buzzed like an angle grinder around my head. Eventually, above its irritating whine, I heard the drone of the Caravan coming to fetch us. Out on the airstrip the next batch of guests surveyed their surroundings with a distinct look of trepidation. 'How was it?' One of them wanted to know.

'*Amayzing,*' I smiled.

(Overleaf)
Dune field and fog.
Skeleton Coast National Park.

132 Namib

(Left)
Desert plants like this Lithops, in stone camouflage, employ strategies to survive both the Namib's harsh environment and predation.
(Above)
Lichens - an association of fungi and algae - thrive in the Namib's fog belt. The thallus remain folded until favourable conditions arrive, when they rapidly unfold, absorb moisture and expose the algae inside.

(Previous spread)
A porcupine freezes at our approach through the morning fog.
(Left)
The presence of their favourite browse - Acacia and Combretum trees - in the dry Khumib riverbed, as well as a permanent spring at Surusas, make the task of living in the Namib easier for this trio of giraffes.
(Below)
Springbok are common throughout southern Africa's arid regions, thanks primarily to their catholic feeding habits.

(Opposite)
A clearly delineated path through the pebbly coastal plain
marks the route followed for years by jackal and brown hyena
scavenging on the nearby Cape fur seal colony at Cape Frio.
(Above)
A black-backed jackal makes off with a seal carcass through the
wind-driven sand.
(Overleaf)
A Cape fur seal bull charges at an intruder on his territory.

(Left)
A washed-up whale carcass near Cape Frio is a massive bounty for these ghost crabs. Specialist scavengers, the crabs live in densities of up to 15 000 per kilometre of coastline.

(Right)
Wind-blown Namib sand piles up in the
slipstream of a web-footed gecko's carcass.

Namib 145

river

Zambezi
ZIMBABWE

Zambezi
GETTING THERE

I HAD UNFINISHED BUSINESS WITH THE ZAMBEZI RIVER. WHEN I WAS GROWING UP IN ZIMBABWE, before independence, the Zambezi Valley was a no-go zone, somewhere our dads went to fight in the 'bush war' that ravaged the country for nearly a decade. My family left Zimbabwe before my thirteenth birthday, and the waterway that missionary and explorer David Livingstone masterfully understated as 'a magnificent stream' remained sorely unvisited.

A magnificent *stream*? Livingstone patently never paddled himself down Africa's fourth largest river in a flimsy canoe, sharing the water with a few thousand bad-assed hippos and more crocodiles than I care to count, sleeping on its banks with lion, hyena, elephants and buffaloes. Had he done as we did, he might've been more inclined to the moniker of 'Mighty Zambezi'.

At the time of our visit, canoeing was about the only way to get anywhere in Zimbabwe. Motorised transport was useless. Under the presidency of the deluded despot, Robert Mugabe, crippling fuel, food and foreign exchange shortages had brought the country to its knees. The dire fuel situation, as well as the government's paranoia about foreign journalists, meant we'd have to get to the river via Botswana and Zambia, limiting our car travel in that broken country to a few hundred kilometres – from the border at Kariba to Mana Pools National Park.

(Previous spread)
Elephant,
Chessa.

NOTE:

In late May 2005, a few months before our visit, the Zimbabwean government embarked on Operation Murambatsvina – designed to 'clean up' the country's cities. A United Nations fact-finding mission into the impact of the destructive operation estimated that up to 700 000 people lost their 'homes, source of livelihood or both' as a result. Zimbabwe was a nervous country, and we were not about to inflame the situation by pointing our unaccredited cameras at the people and places we passed, so they stayed safely stowed in their cases until we reached the Zambezi River.

At Kazungula, we boarded the ferry that connects Botswana to Zambia, and as the two formidable engines powered the pontoon across the Zambezi River, I considered the implications of pointing its nose downstream and cruising to our destination at Mana. We'd be there in a jiffy. Of course, we'd have to negotiate the Victoria Falls and portage around the dam wall at Kariba, but just think of all the time and fuel we'd save!

It was hurdles such as these that prevented Livingstone from realising his dream of using the Zambezi as 'God's Highway' to spread Christianity from the Indian Ocean to the dark interior. Not only did he underestimate the magnitude of the falls, he was also stumped, while travelling upstream from the coast, by the impassable Cahora Bassa rapids in Mozambique. The missionary had to cope with failed ambitions; we had to contend with the immigration rigmarole of three countries.

There was a fee for the ferry, a toll for the road, a levy for vehicle insurance, all payable at different counters in any number of currencies. Yet the Zambian border officials were friendly and almost efficient, and it wasn't long before we were heading along the riverside road towards Livingstone. After reaching this genteel, leafy town we parked outside the bank to go inside and change money. But why queue in a stuffy bank when roving bureaux de change operate in its car park? The money-changers were so flagrant, and honest, this kind of transaction seemed perfectly legal.

Somewhere after Livingstone, I got the sense there was a fuel shortage in Zambia too – maybe it was all those handwritten 'No diesel' signs at the filling stations. We slowed down to 90 kilometres an hour and stopped at every garage, in every town, for the next 350 kilometres. Finally, at Mazabuka, a long line of vehicles streamed into the road outside a garage. We obeyed the African rule of thumb that says: where there's a queue, join it.

Except that in Africa the idea of a queue is still a bit of a curiosity, and soon enough trucks and taxis and pedestrians with containers began to push in from the front. An hour passed. We watched hungrily as vehicles filled first their tanks, then extra drums and jerry cans. Surely the supply would soon run out? But then our turn came.

By now it was late afternoon, and the border was another two hours away. Would we get there before it closed? We were torn between speeding up and conserving fuel. We might've made it if there hadn't been a traffic jam on the road to Chirundu, the major trucking route between Harare and Lusaka.

The road winds steeply down the escarpment through extraordinary scenery to the Zambezi Valley. But it's difficult to appreciate the beauty beyond the stream of belching, overladen juggernauts and the wrecks of their less fortunate compatriots that had plunged down the steep embankments. Some had only fallen halfway and now, rusted and battered, clutched grotesquely at the hillsides.

There was a 30-truck backup on one of the road's hairpin bends, occasioned by a stubbornly immobile pantechnicon squatting across one-and-a-half lanes. The drivers were all incredibly patient – this was just another day at the office, and really, there wasn't much you could do except wait for the self-appointed traffic cops to summon you forward.

It was dark by the time we arrived in the Zambian border town of Siavonga, wandered into Eagle's Nest Restcamp on the shores of Lake Kariba, and pitched a tent by the glow of the car headlights. We wasted no time in heading to the bar–restaurant overlooking a small bay where we ordered crumbed Kariba bream with generous quantities of Mosi Lager. Out on the lake a smattering of lights twinkled from the kapenta fishing boats. We went to sleep to the hum of domestic generators, having debated at length the anomaly of diesel generators beside a major hydroelectric dam.

It was a short hop to the border the next morning. Along the way people waved thick wads of Zimbabwean dollars at us, as if the currency was another roadside curio. We were the only travellers at the Zambian border post and were enthusiastically served by three astonishingly handsome officials – not your typical representatives of the immigration business. We crossed the Zambezi River into Zimbabwe, over the Kariba Dam wall, feeling unaccountably optimistic.

We were invited to cough up for more tolls and fees and taxes at the Zimbabwean border, payable only in US dollars. And then we found the corrupt official we'd been expecting. He sat at a school desk under a tree in the parking lot, fingering a dense Very Important Register. He professed a tremendous amount of authority for someone wearing shorts, T-shirt and sandals. Where was our police clearance certificate for the vehicle? It was a pity we did not have one, because the certificate had to be produced before we could proceed. Yes, it was very interesting that the engine and chassis numbers correlated with the vehicle's registration papers, and intriguing too that no one, not a soul, had ever asked for such a document in 10 years of African travel, but still, the certificate was essential. Maybe there was some way we could help each other? I considered a right upper hook to the nose, followed by a knee in the groin, but Adrian had a better idea.

Adrian explained that we were devastated to have to end our holiday already, but it was our own fault for not having the correct paperwork, and he took me by the arm and began to walk back towards the immigration building. And then something extraordinary happened. The certificate was suddenly not so essential after all, discretion could be used, an exception could be made, we could continue our journey. Our bluff had worked, but we drove into Zimbabwe with a bitter taste in our mouths.

Kariba Dam was completed in 1960 to harness the Zambezi's hydroelectric potential; 86 workers died during its construction, while 50 000 resident Batonka and thousands of animals were displaced by the rising water. Yet for ocean-starved and sanction-weary Zimbabweans, Kariba flourished as a

Zambezi escarpment,
Lake Kariba.

'seaside' resort town when I was growing up. There was a casino and tiger fishing, luxury hotels and booze cruises, island getaways and actual sand beaches washed by knee-high waves on a windy day. Months before we emigrated, my parents splurged on plane tickets, car hire and five nights at a luxury hotel – we were going to have the Kariba family holiday of a lifetime. We all still rate it as one of the best.

Less than a decade later the streets and hotels were filled with international backpackers and well-heeled travellers, while the country enjoyed a tourist boom that put Zimbabwe squarely on the world map as a must-do destination. Ferries and houseboats plied the dam alongside kapenta rigs and day-trippers in motorboats. The place was alive and kicking.

It was difficult to imagine Kariba that way now as we drove through the forlorn streets, catching glimpses of a deserted lake – the marinas crammed with houseboats, berthed indefinitely by the fuel shortage. The curio sellers were gone, the hotels and lodges empty. A desolate, out-of-season sadness hung over the town. At the petrol station, the attendants kept busy cleaning the windscreens of the handful of cars whose drivers knew someone, who knew someone, who could make a plan for fuel.

'Look on the bright side,' said Adrian, 'at least there's no traffic.' And he was right. We barely passed another vehicle in the three-hour drive to downstream Mana Pools.

Zambezi
BEING THERE

Reflected sunset.
Mupata Gorge.

AFTER BUBBLING OUT OF A BOGGY HILLSIDE IN ZAMBIA, THE ZAMBEZI RIVER COURSES FOR 2 700 kilometres before emptying into the Indian Ocean at Mozambique. The river brings water from the wet, high-rainfall regions of Central Africa downstream to the parched south, extending a lifeline to those that live near its banks. Although it passes through Angola for only a few hundred kilometres, it is in this country that the Zambezi gathers most of its headwater drainage.

The waterway washes the shores of six countries on its seaward journey, and forms a natural frontier between Zimbabwe and Zambia. It's here that the river's energy is first reined in. What was Kariba Gorge is now Lake Kariba. The dam's construction has had a major effect on wildlife downstream, where water levels are entirely at the mercy of the region's daily electricity demands. By interrupting the river's natural annual flood, soils are no longer renewed and the land is less fertile, sustaining fewer animals.

(Opposite)
Greenbacked heron.
Vundu.

Mana means 'four' in Shona and refers to the number of large pools – the remains of an ancient channel system – that were cut off from the Zambezi after Kariba was built. Mana Pools National Park was proclaimed in 1975, and, together with Zambia's Lower Zambezi National Park and neighbouring conservation areas, protects over 10 000 square kilometres of the Zambezi Valley.

We arrived in August, the middle of a devastating dry season, following on a wet season that had been little more than an empty promise. Much like the country, the park was ravaged. All the animals congregated around the pools and on the riverfront, where searching lips and weary hooves had turned the shores into a dusty wasteland. Termites had consumed whatever remained. There was no undergrowth to speak of, just towering riverine forests of sausage trees, Natal mahoganies and *Acacia albida* all uniformly cropped to eland head height. Yet the place was unusually beautiful and serene – like some offbeat Garden of Eden – overrun with mangy impala, scrawny baboons, herds of buffalo and lone elephant bulls. All were completely at ease with human visitors; none of them took any notice of us as we made for the rendezvous spot at Chessa Camp.

I was spectacularly anxious about paddling a canoe 123 hippo-and-crocodile-infested kilometres down the Zambezi to the Mozambican border at Kanyemba, particularly since our previous canoeing experience – besides watching *Deliverance* – amounted to a single terrifying hour on the Ntungwe River in Uganda, which, contrary to popular belief, *did* have hippos in it. Hippo and croc attacks on the Zambezi are rare, but occur often enough to be considered a real danger. Yet more than one person had told me I would be in excellent hands. James Varden was reputedly one of Zimbabwe's most responsible, knowledgeable and experienced guides.

So I was a little alarmed when the co-owner of Natureways turned out to be a boyish redhead, who moments earlier had been standing thigh deep in the channel in front of an elephant bull foraging in the water. Admittedly, he was indulging a departing client's desire for close-up photographs of the elephant, while our other host, Mike Woolford, had been on standby in the getaway canoe. Both of them were barefoot, dripping wet and in high spirits when we sat down to tea and cake to meet the rest of the team.

River guide Fisher Ngwerume, the tall, reserved, father of twin three-month-old daughters, would take up the back-seat steering position in my canoe and prove to be a wonderfully skilled, unflappable companion. (Just as well. If it had been left to me, I'd still be paddling in baffling figure eights in front of the camp.) Tendai Ketai, the outfitter's mechanic, in training for his river guide's license (a sensible career move in light of the fuel crisis), would double as the camp cook, and share a canoe with Mike. Mike had lived and worked in Zimbabwe as a professional hunter, become disillusioned with the business after one too many bloodthirsty clients, and now spent his days cheerfully shoeing the horses of Sweden.

Camp site,
Chessa.

'Hey, look everyone, there's a gymnogene!' Mike exclaimed, pointing to a large raptor landing in a far-off tree. 'We must sing the gymnogene song.'

'We love gymnogenes,' James began tunelessly, and then stopped.

'That's it?' I asked.

'Um, yes, we're still kind of working on it,' Mike confessed.

It was soon apparent that James and Mike not only shared a longstanding friendship and a peculiar obsession with gymnogenes, they also had a healthy respect for the river's Nile crocodiles, which they referred to in whispers as Mr Snaggly Tooth. A week on the river with these two was going to be interesting. As the only woman on the safari I was also going to have to suffer the double entendres and locker-room humour of five grown men on a jolly boy's outing. At the first opportunity I laid down the Golden Rule of cross-gender etiquette: no farting during meals or in the general area of what could reasonably be considered the kitchen.

Hippos eyed us from the far side of the narrow channel as we boarded our canoes the next morning. The safety briefing was just that, brief. We were to give the hippos the deep water at all times, and to do what we were told in the event of capsizing. That was it? No secret strategy to prevent death in the jaws of a crocodile?

Our boats sat low in the water, packed to bursting with everything we'd need for the expedition: tents, bedding, clothes, food and gas bottles, all tightly secured to the vessel in the event of a spill. The guides were armed to the teeth – just in case. James, Mike and Fisher each packed Smith and Wesson side arms; there were two rifles for land-based firepower, as well as a healthy collection of hunting knives. Mike's dagger boasted a hippo-tusk handle and a deadly blade, forged by a Swedish blacksmith who'd imbued it with Viking magic – at no extra charge.

I was trembling as we set off, and paddling awkwardly, my knuckles catching the boat with each downward stroke. Fisher told me to relax, slow down, we had all day. He pointed out waterbuck grazing on a flood plain and herons patrolling the shallows. We travelled slowly along the side channels that hug the wooded shores. Winter bush fires had smoked the sky a dull white. I could barely make out what must be a dramatic escarpment on the Zambian side. The haze was so thick it was almost

(Overleaf)
Canoe trail,
near Chikwenya Island.

tangible. Not that I was doing much sightseeing.

I was preoccupied with searching for hippos, crocodiles and tree stumps. Fisher made a spirited attempt at taking my mind off the hazards. So, while I obsessively pointed out 'hippos at two o'clock,' he would typically reply with a 'whitecrowned plover on the left,' and gently steer us out of harm's way. We came across our first mammoth crocodile basking on an island directly ahead of us. I froze when it slipped into the water and disappeared from view.

Crocodile imprint, Mupata Gorge.

'Ohmygod, huge croc at twelve o'clock somewhere. Quick, what do we do?'

'Do you have binoculars?' asked Fisher.

'*Binoculars?* Yes, *why?*'

'Then look at the eland on the mainland over there,' he replied.

I began to settle in and relax after a few uneventful hours. The current and Fisher did most of the work while I rested my arms between strokes. I started to take in the scenery: fish eagles terrorising little egrets, pied kingfishers hovering in the shallows. As the sun rose higher I was mesmerised by the glittering mica in the sand of the shallow channels.

Applying a third layer of sun block, I resolved that the deadliest threat to a canoeist on the Zambezi River was skin cancer. At that precise moment, Adrian and James in the lead canoe surprised a hippo hidden in a deep, narrow channel. As it exploded beside their boat, we were all yanked out of our comfort zones, all cursed in unison and all began to paddle like there was no tomorrow. We emerged into the main river giggling nervously, shaken, but dry and unharmed.

After that, I learnt that the hippos you could see weren't nearly as scary as the ones you couldn't. And when the waters appeared free of pink nostrils and piggy ears, the guides tapped the side of their canoes to alert submerged hippos to our presence. Common wisdom holds that herbivorous hippos are not in the habit of hunting and attacking canoes and their helpless cargo. The fat grass-eaters are simply protecting their territory against intruders, and if they happen to chomp your boat in half, well, you asked for it, rudely trespassing like that.

Buffalo herd,
near Chessa.

At lunchtime we disembarked into the shady embrace of Chikwenya Island, which has been hosting weary travellers since Livingstone's day. While Tendai prepared cold meats and salad, Mike took off with his fly-fishing rod and Fisher and James cocked their rifles and guided us on an armed exploration of the island. Towering mahogany, *albida* and fig trees allowed only small shafts of sunlight to penetrate the canopy, and the forest oozed a damp, jungle-like odour that reminded me of Bwindi. We found baboon, buffalo and elephant spoor and a juvenile Pel's fishing owl that glared at us with coal-black eyes from its lofty perch in a fig tree.

The Zambezi was at its most tranquil in the late afternoon. We paddled into a shallow channel and drifted towards a large herd of buffalo drinking at the water's edge. They paid little attention to us and it was only when we'd approached to within a few metres of their black shiny noses and hooked horns that it occurred to me this was something I'd never dare on foot. Yet here I was, floating on a piece of fibreglass, not even three buffalo-strides from certain death, feeling totally invincible.

Around the corner we came across a massive elephant bull, up to his shoulders in the water, devouring the green foliage of a tree that had tumbled into the river. Slowly, we inched towards him. He ignored us, even after we flushed a pair of rarely seen whitebacked night herons. They took to the air scolding us with a grating 'kaark, kaark' for disturbing their siesta in a tangle of shoreline vegetation. We anchored against the broad base of the fallen tree – within trunk's reach of the bull. He didn't so much as look at us. His tusks had been whitewashed in the river, and I noticed a small chip in his left tusk, and a tiny spider making its way towards his right eye. His eyelashes were as long as my index finger. It was an act of will to restrain myself from slipping into the river beside him and clambering onto his broad back, which glistened black in the water. I practically *sat* on my hands to suppress the impulse to stroke his trunk as it investigated some leafy bits within inches of my canoe. The experience was so exhilarating and absorbing, I think I forgot to breathe.

As the sun paled in the smoky sky behind us we made for a low-lying, treeless slab of sand scattered with clumps of long grass. We assembled our tents – simple gauze structures that kept the

mosquitoes and creepy-crawlies out, without spoiling the view of the night skies and surrounds, then Tendai and Fisher whipped up dinner, James wandered off with his bird book and Adrian and Mike took up the fly rods.

My bucket bath was interrupted with the news that Adrian had caught his first tiger. The contest was hardly fair; he'd hooked a sorry-looking, one-eyed specimen that in all likelihood threw itself on the hook in a final, desperate act of suicide. While a yellow moon clawed its way through the dark haze, we sat down to spaghetti bolognaise and enamel mugs of red wine, and contemplated our response time should the crack-riddled Kariba Dam wall give up the ghost during the night. Or what if all the Zambians and Zimbos felt like a cup of tea at the same time? Would our camp site be flooded by the hydroelectric demands of 25 million kettles?

The sun did not so much rise as cough its way, like a red-faced ball, through the white sky the next morning. We quickly slotted into the routine that would dominate our days on the river: pack up, eat breakfast, follow James on a walk, paddle for a couple of hours, stop to explore an island, back in the boats until lunch and siesta, canoe until evening, set up camp and maybe squeeze in a round of sunset Frisbee before dinner. Afterwards, Mike would sneak out a miniature teabag of *snus* (Swedish chewing tobacco) from his jealously guarded stash and we'd make up silly words and tunes for the gymnogene song. *I'm a gymnogene and I'm okay ... eating squirrel pie all day.* Occasionally lions roared or hyenas whooped during the night, but the snuffles and guffaws of hippos were a constant soundtrack to our dreams. I was grateful then that Mr Snaggly Tooth was mute.

The ache that originated in my shoulders and stretched to my fingertips began to subside after two days and I started to paddle more proficiently. My fear of the river had dissolved from sheer sphincter-loosening terror to mild unease. The days passed slowly, each distinguished by a special sighting: Samango monkeys in Zambia, a lioness at Chewore River mouth, bats inside the hollow base of a baobab tree.

Walking trail, Mucheni.

One morning James declared it was time for a 'bit of a legover.' I looked at Adrian anxiously, thought of *Deliverance*, and wondered just what it was James had in mind. But 'legover' turned out to be canoeist-speak for hitching the boats together by hooking your ankle into the neighbouring canoe and travelling downstream as one. The current toyed with our flotilla and we drifted in lazy circles, facing Zimbabwe one moment and Zambia the next. Adrian photographed wagtails racing us downstream, perched on floating clusters of detached Kariba weed, while Mike trailed a fishing line behind the boat, each of us occasionally making monumentally mindless conversation.

That was the day the wind arrived, bullying us like some brash, uninvited guest. It was a headwind that gusted and resisted us as we tried to cross the river and enter a sheltered channel, the entrance guarded by a gang of hippos. The skinny channel turned out to be the home of a nervous mother hippo and her newborn calf. The hippo pair disappeared underwater, so we clung to the steep channel banks for an age, waiting for them to surface. When that didn't happen we forged ahead, past the biggest crocodile I never hope to see again.

'Tomorrow we dip our paddles and penetrate the gorge,' James announced to a schoolboy twitter over dinner one night.

The Zambezi changes character every 10 kilometres or so and no more dramatically than at the Mupata Gorge. 'Mupata means "narrow" in Shona,' Tendai explained, as the wide sandy river began to thin, channels disappeared and steep hills replaced the expansive flood plains. Eventually we were funnelled into a canyon that was only a Frisbee throw wide in parts. The current became stronger as we entered the gorge. It was our turn to take the deep water as hippos kept to the banks, shunning the fast flow in the middle.

Mike took out his GPS, we all paddled as hard as we could and he measured a top speed of nearly 16 kilometres an hour. But the gorge only stretches for 46 kilometres and we were in no hurry to pass through it. The conditions were perfect for a legover, so we all sat back and let the river transport us at a leisurely seven kilometres an hour instead.

Baobabs and other trees, stripped bare by winter, tripped down the boulder-strewn hillsides ending abruptly in a line of green riparian forest that hugged the water's edge.

Every so often baboon troops foraged in the riverside umbrella thorns. We passed a midstream rocky island, home to a pair of rock pratincoles, intra-African migrants to the Zambezi between June and August. These birds seek out inaccessible islands, like this, to lay two or three eggs on bare rocks. They time their breeding to coincide with low water levels, fledging their chicks before flood waters inundate the island. I doubted that they'd calculated over dinner what hydroelectric output might do to their nest.

Eddies spun us gently around so that we'd call out sightings of 'Zambian bushbuck', 'Zimbabwean warthog' and seemed to spend most of the day floating backwards, staring upstream. We had left behind the motorboats, camp sites and safari lodges characteristic of the upper river. The gorge was all ours. We camped on a flattened sand dune that night and laughed and swapped stories while fireflies danced over the Zambezi. I felt safe and content and happy to stay in the gorge forever.

A few hundred metres on the next morning, Fisher pointed out the marks in the rocks where water engineers proposed constructing a wall that would impound the Zambezi into an 85 000-hectare lake, flooding the gorge and obliterating everywhere we'd been, including Mana Pools National Park. What? It was inconceivable that anyone should be allowed to destroy this sensational stretch of the river.

In 1982 the Zambezi Society was born out of a lobby group that opposed the Mupata Dam. They petitioned successfully for Mana Pools to be designated a World Heritage Site, earning the Zambezi Valley a reprieve from another concrete monstrosity. Still, plans are afoot to dam the Batoka Gorge, just downstream from the Victoria Falls. Although this dam would have significantly less environmental impact, the ecological cost of hydropower remains unacceptably exorbitant.

As we passed through the two pillars of rock, 'The Gates', guarding its exit, we left the sanctuary of the gorge and were immediately accosted by the brutal headwind. The Gates signalled the end of the wilderness, at least as far as the Zambian side was concerned. Villages appeared almost immediately, and, for the first time, other canoeists – subsistence fishermen in dugouts.

The sight of the villagers was somewhat humbling. I had been patting myself on my newly muscled back for making it this far on my own steam and roughing it in the wilderness. But really this had been a fleeting, soft adventure. For the old men battling the wind in their dugout, the hippos and crocs and wily fish made for a life of constant struggle. We had watched a woman on a reed-lined shore angrily beating the water with a stick. As we floated closer she smiled shyly and waved. No, she was not cross with the river, she was fishing for tiger – without the benefit of a reel – whipping a line of fishing gut across the surface. 'Look at that, Mike,' Tendai pointed out, 'Proof that fly-fishing originated in Africa.'

We stopped at the towering massif known as Red Cliffs (on account of its fiery glow at sunset) to bail water out of our boats. The wind had hurled metre-high waves at us, and Adrian and James' canoe was sitting perilously low in the water. It was as if we'd angered the Zambezi and now it was throwing a tantrum. My eyes were streaming, my arms burning with the extra effort of rowing in the gale, and my nerves were shot. The gust had brought with it all the terror of the first day as well as a generous dose of tetchy hippos and sinister crocs. I was sure that Fisher felt the same way until I heard him humming softly to himself, oblivious to our pending death.

Canoes,
Vundu.

The gale slowed our progress so that we ran out of daylight and had to settle for a waterlogged camp site. I was happy to be on land again and guiltily looking forward to the end of the trip the next morning. 'Robyn, are you okay? I think you need this,' Fisher declared, handing me a mug of wine immediately after we docked. The waves had wet most of our bedding and the guides kindly offered us the driest available. After supper I fell asleep to village sounds and Mike and James singing, 'Imagine there were no gymnogenes,' as they tried out lyrics to every imaginable John Lennon and Beatles tune. The wind howled all night.

The last day dawned with the Zambezi in a better mood. We paddled for an hour or so and then it was all over. We turned into an opening in the reeds where a car and trailer waited for us outside a deserted army barracks. But I wasn't ready to get out, after all, in spite of my feelings the previous wind-bullied day. I had expected to feel relief, but now I felt only regret. I wanted to follow the river just a little bit further, just to see what personality awaited us around the corner.

Besides, we hadn't finished the gymnogene song yet.

(Left)
A pall of smoke from fires in neighbouring Mozambique makes for a dramtic first night's sunset on the Zambezi River.

168 Zambezi

(Previous spread)
Although they are mostly solitary when feeding at night, hippo usually gather in small herds during the day - alternating between sunning on the shores or cooling off in the shallows.
(Above)
A hippopotamus breaching - an unwelcome sight to a canoeist.

(Previous spread)
A pair of buffalo bulls charge through the midstream shallows near Chessa.
(Above)
As dusk falls, flocks of waterbirds - like this line of Egyptian geese over the river at Vundu - begin to congregate and fly to their roosting spots downstream.
(Opposite)
A flock of glossy ibis silhouetted against the escarpment.

(Previous spread)
Thousands of Cape turtle and laughing doves gather to drink each morning. The flocks are under constant attack from avian predators, who sometimes strike down more birds than they can eat.
(Right)
A male chacma baboon makes sure nothing goes to waste.

(Opposite)
Inside the hollow trunk of an ancient baobab lie the skeletons of two chacma baboons - possibly victims of a furtive leopard that brought the carcasses into this sanctuary to feed.
(Above)
Our presence inside the trunk disturbs roosting bats into flight.

182 Zambezi

(Previous spread)
An elephant cow charges our passing canoes.
(Left)
In a more docile show of maternal care, a cow drapes her trunk over a very young calf in the midday heat.

(Right)
At dusk, a small herd of
elephants crosses back to
the mainland after spending
an afternoon feeding on an
island near Chessa.

Zambezi 135

mountain

Table Mountain
SOUTH AFRICA

Table Mountain

WHEN THE DUTCH EAST INDIA COMPANY WAS LANDLORD OF THE CAPE, THE FIRST SAILOR ON ITS ships to sight Table Mountain was rewarded with a case of wine, and his shipmates a tot of brandy. How times have changed. The day after I spotted the mountain from a boat in Cape Town's harbour, I was fleeced R9,50 for a warm Coke on its summit.

I had boarded the *Shosholoza*, a small cruise boat captained by Jacques, a stout young Afrikaner from the Free State. As Jacques manoeuvred the boat to give us a full view of the sandstone and shale massif that dominates the city, I understood why the region's first inhabitants, the Khoisan, called it *Hoerikwaggo*, Sea Mountain. Visible some 200 kilometres out to sea, Table Mountain rises from the Atlantic like a denizen of the deep. The flat-topped mountain, flanked by the peaks of Lion's Head to the west and Devil's Peak to the east, steadfastly guards the southern edge of the continent, the ocean practically cowering before it.

We circled the docks while Jacques filled us in on harbour scandal and titbits: there were impounded diamond dredgers; seldom-used playboy yachts and rustbucket tuna trawlers operated by unsavoury characters; a hamburger at a particular harbour-side hotel would set you back a hundred bucks (which makes the Coke seem like a bargain, I suppose). As we cruised back to shore, I noticed, with some trepidation, the footslog that lay ahead of me that day through the city to my distant

(Previous spread)
Table Mountain,
view from Bloubergstrand.
(Opposite)
Children on swings,
Sea Point.

destination on the slopes of the mountain. Would I still have the legs, over the coming days, to walk along the spine of the range, from the tabletop to the southernmost tip of the Peninsula?

Until 1647, the Cape had been little more than a pit stop for European ships on their passage to India. It offered sheltered bays and an endless supply of fresh water off the mountain. But after a Dutch vessel was wrecked in Table Bay, and its crew managed to make themselves at home for a year, the Dutch East India Company rather fancied the idea of turning the Cape into a permanent settlement. The company was not after a colony, just a base where it could park its ships, grow its own vegetables and barter meat from the resident Khoisan to provision its fleet.

Five years later Jan van Riebeeck arrived, planted a hedge to keep the Khoisan out, invited a handful of middle-class citizens to establish farms, then set about importing slaves from Mozambique, Madagascar and Indonesia to handle the heavy labour. By the time slaves were emancipated in 1834, Cape Town, as the city came to be known, was a gulag to over 30 000 slaves.

I wandered up from the docks to the previous haunt of these unfortunate souls. The area has become trendy, in the warehouse-conversion fashion, and now houses elite advertising and interior décor businesses. But Gallows Hill, where criminals were publicly executed from the top of a sand dune, still casts a shadow over the suburb, its precinct currently occupied by the city's traffic department.

Sightseeing bus, near Camps Bay.

I turned down Prestwich Street and stood on a corner across from where labourers in hard hats operated heavy machinery to build the foundations of a multistorey office and retail complex on top of a slave graveyard. When the site was excavated in 2003 to prepare for construction, 2 000 unmarked graves were inconveniently discovered. Archaeologists revealed that the bodies had been shabbily stuffed into shallow pits; in some cases three skeletons were buried on top of each other, and only a few were enclosed in coffins.

Toting faded daypack and wearing sensible shoes, I was not properly dressed for the next block. De Waterkant is just too trendy for its Tommy Hilfiger T-shirt, and I dashed through the reinvented village, avoiding eye contact with the stylish inhabitants, who had happily dropped serious cash to live or work in the erstwhile slave district.

When I looked up again I was in Chiappini Street on the slopes of Signal Hill, surrounded by the friendly pastel-coloured homes of the Bo-Kaap. Now this was the real thing – the city's oldest residential area, preserved by its predominantly Muslim residents, many of whom are descendants of the slaves who lived in the colourful houses in the early 1800s.

The village is often referred to as the Malay Quarter, although few slaves actually hailed from what is now Malaysia (most coming from other company trading areas like Java and Bali). Many Indonesian princes and Islamic leaders were also brought to the Cape as prisoners, and they formed the nucleus of the 'Malay' community.

I stopped at the Bo-Kaap Bazaar in Rose Street for some chilled fruit juice and a *koesister*, a spicy doughnut-like treat laced with cardamom (not at all like the plaited Afrikaans *koeksister* that I've grown fat on). Zani, the slender, graceful proprietor, who had converted the front room of her house into a tearoom, explained that, in the old days, if a wife surprised her husband on a Sunday morning with *koesisters*, there wasn't a thing she couldn't get him to do around the house. Note to self: obtain *koesister* recipe.

Down the road, a minibus taxi hooted, and a grinning passenger called out, 'Lady, we'll take you up Table Mountain!' I smiled and waved them off; I still planned to see Greenmarket Square, the cobbled plaza that once served as the city's fresh produce market; as well as the architecture of the City Hall, which stands as a record of the British occupation of the Cape. Besides, taxis can't go up Table Mountain.

Lodge decoration,
The Wash Houses.

The British captured the Cape in 1795, apparently with the sole purpose of test-driving it, telling Holland eight years later, 'No thanks, old sports, you can keep it, we're not in the market for a new colony after all.' Three years after that, the fickle imperialists returned with guns blazing and pointed out, 'Actually, chaps, second thoughts and all that, we'd rather like to try the Cape again, and if it's all the same to you, we'll take it for good this time.'

I was strolling through the flower market, where toothless matrons offered me 'Nice proteas', when the Noon Gun boomed that it was lunchtime. Presently situated on Signal Hill, the Noon Gun – actually a pair of cannon – was originally fired to announce the arrival of important ships. The news would reach the interior and farmers would head over the mountain to the docks to sell provisions to the visitors. Since 1806 the guns have kept time, firing at 12h00 to allow sailors to set their chronometers, the instrument by which they measured longitude. Technology has moved on, but the tradition continues – except for one day in January 2005 when thousands of Capetonians forgot to eat lunch. Both the main and backup gun failed to fire – the first time in 200 years.

My toes began to ache and the going became increasingly steep as I hiked among grey squirrels and pigeons up the shady avenue of the Company's Gardens. A good chunk of Van Riebeeck's original vegetable garden survives as an attractive green space in the heart of the city. The stone canals that drained water from the mountain to nourish the vegetables still run alongside the avenue that hosts the National Library, National Gallery and Tuynhuis (the President's city pad).

It was late afternoon by the time I exerted myself up Oranjezicht's long hill to my destination – the city's first laundromat, alongside the Platteklip River on the slopes of the mountain. It was to this mountain stream, called Camissa ('sweet water') by the Khoisan, that eighteenth-century slave women hauled their masters' laundry. A row of the original stone wash houses has been renovated by South African National Parks to provide overnight accommodation, decorated with funky township art and recycled crafts, for footsore walkers.

After a tasty three-course Malay *rijs tafel* – a traditional feast of samoosas, bobotie (spicy mince topped with custard), chicken curry, roti (flat bread) and a face full of dessert – I negotiated a violently vertical ladder up to my loft room. There the craggy face of Hoerikwaggo stared at me through the skylight while I slept between white cotton sheets.

(Right)
At an Oudekraal curio stall, two tourists appraise giraffe carvings.

Table Mountain
BEING THERE

Erica phylicifolia,
Solole Game Reserve.

Geologically speaking, today's 1 086-metre-high Table Mountain is on its last legs, weathered down from a height of 6 000 metres. It all began between 600 and 800 million years ago, when the southern reach of Africa lay on the ocean floor. Ancient rivers emptied into the sea, dumping loads of sediment that drifted far out into the ocean, depositing layers of the finest grains on the continental shelf. These layers eventually compressed under their own weight into Table Mountain's oldest rock masses, the Malmesbury Shales. Then, 550 million years ago, our fidgeting planet was up to its old tricks when tectonic collisions caused molten rock to push up from deep in the earth's mantle and intrude into the shales before cooling slowly into granite. Meanwhile, sediments continued to be laid on top of these rock formations, still visible today as Table Mountain Sandstone. Finally, around 180 million years ago, the super-continent of Gondwanaland (encompassing most of

(Opposite)
Wooded gorge,
near Victoria Dam.

today's southern hemisphere land masses) began to split up, causing the earth's crust to buckle and forcing Table Mountain six kilometres into the sunlight and fresh air above sea level. The eroded pile of sandstone that remains – I've heard geologists refer to it as a lump of mud – is the pride of every Capetonian, as well as a world-famous icon. In 1998, the mountain chain, stretching from Signal Hill in the north to Cape Point in the south, was declared a national park.

Guidebooks will tell you that getting to the top of the mountain can be a lengthy and demanding pursuit. I did it in four minutes, practically flew up at five metres a second (with a little help from the Table Mountain Aerial Cableway Ltd). Of course, that's not counting the steep climb to the lower cableway station from the wash houses, which had me gasping for breath and emptying my wallet for that Coke at the top – apparently the can was included.

Tour groups clustered near the upper cableway station, gushing about the spectacular views on an unusually calm Cape day. To my left spread the Twelve Apostles and the protected Oudekraal area, where a tar road followed the coastline until it disappeared, swallowed by the mountain range, beyond which riders galloped horses across the beaches of Noordhoek and Hout Bay. To my right I could see the upmarket suburbs of Clifton and Camps Bay. You couldn't tell from this height, but that was where the beautiful people gathered at pavement cafés for lattes, joggers coerced pet dogs into their training schedules, and sun-worshippers prostrated themselves in homage on white beaches washed by ice water fresh from the Antarctic. Further to the right lay a sparkling Table Bay and the harbour and, gosh, what a long stroll I'd taken yesterday.

Following a path that led precariously along the edge of the mountain, I began to lose the crowds as I headed towards Maclear's Beacon, the mountain's highest point. Brushing off the vertigo, I peered down the rugged slopes, where burnt grass and blackened twigs clung to the mountain face. Two months earlier, a tourist had flicked a cigarette butt out of his car window and,

Cable car, Cape Town.

in the ensuing blaze, a hiker was killed and hundreds of acres of wilderness, from Platteklip Gorge to Lion's Head, were destroyed. Yet skinny blades of green grass were beginning to push through the ashes; in another month or so the mountain would be flourishing.

The city was an ever-present traffic drone as I made my way across the tabletop. But in places the mountain still maintained an aura of wild inaccessibility. There were steep ravines and shadowy gorges that oozed dankness and fertility, where I felt completely cut off from urban life. In these wooded sanctuaries only the tranquil fluttering of wings in the canopy broke the silence.

Further along, the trail passed through eroded sandstone boulders that contorted themselves into shapes of rhinos, hippos, camels and great white sharks. Fearless Cape crocodiles – actually girdled lizards (the spitting image of Mr Snaggly Tooth, if he were black and 30 centimetres long) – basked on the rocks alongside the trail. I soon decided that the most dangerous life form on the mountain, besides five varieties of venomous snakes, is the blister bush. An unimpressive, celery-looking shrub that is spectacularly averse to being stroked, *Peucedanum galbanum* excels at inflicting painful blisters (which thrive with the smallest dose of sunlight) on any hiker careless enough to touch it.

It felt like some joker had booby-trapped my boots with blister bush by the time I reached Maclear's Beacon – a trigonometrical cairn of stones rising to 1 086 metres. I hadn't really walked the boots in properly and I found myself shuffling up to the beacon like someone trying not to soil their shorts. After placing a small stone of my own on the pile, I looked around for a shady spot in which to die quietly. But there was no shade, just a treeless expanse of dull scrubby heath as far as the eye could see. For the moment I was in full agreement with the city botanist who, in the 1830s, imported forests of fast-growing invasive shade trees that have subsequently become the bane of today's conservationists. Oh my Cape Floral Kingdom for a big shady eucalyptus, I thought, as I squeezed into a skinny shadow on the south side of a boulder.

As it turns out, the dull scrubby heath that gets locals so excited belongs to the smallest and most concentrated of the world's six recognised plant groups – the Cape Floral Kingdom. What's more, fynbos, as the scrub is known, boasts substantially more species per square kilometre than a South American rainforest. Apparently there are 1 470 different species of fynbos on Table Mountain alone – although you'd never tell by looking. Clearly, fynbos is an acquired appreciation.

I once had a great uncle who called it *vuilbos* (dirty bush), largely because the Homeowners Association of the nature reserve in which he lived took umbrage after he cleared every last 'weed' of it to accommodate a lawn and flowerbeds. This was, of course, the same nature lover who attached the garden hosepipe to his car exhaust to gas the golden moles that were 'eating the rose bushes'.

I had an opportunity to rethink my first impression of fynbos a few days later. A Capetonian friend joined me one bright morning in the low-rise mountains at the Cape of Good Hope, the southernmost tip of Table Mountain National Park, to deliver a lesson on fynbos appreciation. As we hiked, he pointed out its three characteristic plant groups: ericas (small-leaved evergreens); restios (grass-like reeds); and proteas (tough-leaved shrubs). He bent down, picked at a drab-looking specimen and emerged with red blood on his fingers. Incredible, a plant that bleeds haemoglobin.

The further we walked, the more I began to care about this little plant kingdom. We stopped alongside a king protea bush, South Africa's national flower. There, on a pink-and-white flower the size of my head, sat a striking long-tailed bird with a scimitar-like beak. For the Cape sugarbird, proteas are a one-stop shop. Not only do the birds use their long beaks to feed on the flower's nectar, they also nab insects and spiders that visit the flowers. Female sugarbirds build nests in the bushes, using fluffy protea seeds for the soft furnishings.

What the protea is to the sugarbird, the erica is to the orangebreasted sunbird. A couple of iridescent green and orange males flitted fearlessly alongside us while we walked. As if their flashy plumage wasn't enough, they drew even more attention to themselves with their loud 'chink-chink' conversation, while they fed on the tubular offerings of a flowering red erica.

Fynbos provides excellent real estate for little bugs, too. Restios supply scaffolding for the architectural masterpieces of the orb-web spider, while a species of fly exclusively patronises five varieties of flower – all pink with red markings. To avoid inter-species pollination, each flower deposits pollen on a different patch of the fly's body. And, in this plant kingdom, pollination is not the preserve of birds and insects. A variety of mice and shrews do their bit for some species of low-growing protea when they plunder the nectar-rich flowers.

What had begun as a clear, calm morning rapidly turned into a gusting, wet day. The weather is Cape Town's best-kept secret. And the secret is this: it sucks. As squalls thrashed us on the mountainside I had new respect for the brave little flowers that endure hot dry summers, gale-force winds, miserable winters and devastating runaway fires. Although some species of fynbos depend on the occasional fires to survive, the frequency and searing heat (fuelled by alien vegetation) of the fires is taking its toll on the Cape Floral Kingdom.

King protea sepals. Solole Game Reserve.

Struthiola dodecandra,
Silvermine.

Finally, the weather got the better of us and we made our way down to the rocky coastline, where a troop of chacma baboons foraged along the shore for sand hoppers and shellfish. After 350 years of human occupation (read guns and bullets) there's not a whole lot of mammalian fauna left on the Table Mountain chain for us latecomers. Where once there were lions, hippos and rhinos, today there's little else besides elusive klipspringers and tourist-tamed dassies (rock hyrax). But south of the city, one man is doing his damnedest to turn back the clock.

Lindsay Hunt, one-time hunter and founder of Solole Game Reserve, is on a mission to repopulate the Peninsula with animals that previously roamed there. What started out as a two-and-a-half-hectare sanctuary against urban sprawl has grown into a 350-hectare game reserve overlooking the Noordhoek Valley that is now home to herbi-vores like eland, bontebok, hartebeest, springbok and Cape buffalo.

I followed Lindsay on foot one afternoon to look for Mokwena, the Peninsula's only black rhino. We found him halfway up a hillside that commanded an extraordinary view over Noordhoek beach and the turquoise ocean beyond. He didn't look at all out of place in the fynbos. Mokwena stopped browsing for a moment, regarded us short-sightedly and tottered a few steps closer. I was suddenly very fixated with the sharp pointy thing above his nose. But, after squinting myopically beyond us towards the view for a few minutes, he soon lost interest and resumed his delicate browsing.

Chacma baboons remain the only frequently seen large mammal on the Cape Peninsula, but these beleaguered primates face an uncertain future as baboon–human conflict increasingly takes its toll on their diminishing numbers. It's the age-old story of two species competing for the same resources – food and territory. Bored with grass and shellfish, the baboons raid the picnic site dustbins and intimidate tourists into relinquishing the contents of their daypacks – mostly because imbeciles continue to feed the animals. Outside park boundaries, baboons pillage the fruit trees and fridges of suburbia, masterfully breaking and entering homes like accomplished cat burglars. Although the Cape Peninsula population is the only one in Africa that enjoys protected species status, the troops continue to be shot, poisoned and injured by their hairless cousins.

The Baboon Matters project took baboon matters into their own hands in 1999, employing eight men from a nearby impoverished community to monitor the troops daily and steer them out of

conflict areas. To raise awareness, and affection, for these incredible animals, the project facilitates walking tours with select troops as they spend the day foraging across their home range.

On my last morning in Cape Town, Jenni Trethowan, the project coordinator, invited me to join her and the Slangkop baboons on the low mountains overlooking the Noordhoek Valley. It was the highlight of a week on the Peninsula. Mothers suckled newborn infants and dug in the soil for roots near my feet. Juveniles tumbled, head over heels, down the hillside, scrambling after each other through bushes and alien trees. Adult males strolled past, within metres of me and my daypack, without so much as a glance. 'This troop doesn't associate us with food,' Jenni pointed out. And a good thing too, since I dare say my stash of sunscreen, plasters and anti-inflammatories might've been a bit of a letdown.

It was incredibly peaceful, sitting amongst the troop staring out at the sea and the mountains while they grunted to each other, scratched up seeds and crunched on tough roots. The valley below was overrun with roads, houses and shopping centres, yet on the mountain slopes, above an obvious building line, there remained a vast, exquisite chunk of protected wilderness. Surely the Peninsula was big enough for the amiable coexistence of both species of primate?

It occurred to me then that my journey had come full circle. I had traversed the grasslands, hiked the rain forest, snorkelled the delta, explored the desert and canoed the river. Now here I was, squatting on a mountainside again, with sore feet and a troop of primates. It was probably time to go home.

(Left)
A Leucospermum bush cowers under inclement coastal weather rolling over Cape Point. In winter, the plant produces pincushion flowers, varieties of which are common in the international flower trade.
(Below)
A cluster disa at the top of Nursery Ravine.

(Above)
Riding the updrafts along the edge of Table Mountain, a rock kestrel scans for prey.
(Opposite)
A raptor soars against the distant Hottentots Holland range.
(Overleaf)
The Cape sugarbird is a specialist feeder on the pollen of proteas. Here, a male, distinguished by his elongated tail, visits a king protea.

(Opposite)
An orb-web spider stands guard over her silk-wrapped prey.
(Below)
A black girdled lizard - a confiding species regularly seen on Table Mountain - suns itself near the Overseer's Hut.

(Right)
A troop of chacma baboons
suns and plays on the slopes
oerlooking Noordhoek.

Table Mountain 217

218 Table Mountain

(Opposite)
A young baboon enjoys its mother's embrace. Infants like this have pink skin and black coats until they are about three months old.
(Above)
Grooming is one of the mechanisms used to maintain the complex social bonds in chacma baboon society. Here, a female inspects a companion's long coat - a feature distinctive of Cape baboons.
(Overleaf)
Baboon troop, Kommetjie.

Acknowledgements

African skimmers, Okavango, Botswana.

AN UNDERTAKING OF THIS NATURE IS NOT A SIMPLE ONE — ESPECIALLY ON THE LIMITED BUDGETS that are the bane of our existence at the tip of Africa. We have to call in favours from friends and contacts – in the hope that we are some day able to repay them. And so, to those below, those that we have forgotten to mention, and those we met and never got as far as exchanging names with – taxi drivers, pilots, waiters, rangers, cleaning staff, chefs and all others – our sincere thanks:

John & Debbie Addison, Moses Akyoo, Nick Aslin, Charl Badenhorst, Tanja Berndt, Link Botha, David Bristow, Lloyd & Sue Camp, Laura Campbell, Max Christopher, Ian Clarke, Brent Dacomb, Marc de Jager, Roger & Pat de la Harpe, Johan & Elsa de Villiers, Guy de Wet, Bernie & Adrienne Esterhuyse, Melissa Ferguson, Marcel Golding, Paul & Jane Goldring, Anthony Grote, Dave Hackney, Linus Hanabeb, Tony Hardwick, Paul Henning, Wayne & Venessa Hinde, Lindsay Hunt, Luke Hunter, Fatima Jakoet, Fiona Kalk, Adam Kapinga, Brian & Elaine Keene-Young, Bronwyn Keene-Young, Tendai Ketai, Megan Knox, Stephen Lamb, Bev Lobjoit, Suzie Lumsden, Medi Lwere, Donovan Lyimo, Julie Mackenzie, Natalie Masseus, Liz McKee, Taryn Möhle, Lawrence Mugisha, Rogers Muhumuza, Nelson Musoke, Grant & Sharon Nel, Graham Nel, Phuraki Ngoro, Tabby Ngoshi, Fisher Ngwerume, Nico Olivier, Don Pinnock, Michael Poliza, Eric Reinhardt, Oscar Rodgers, Veronica Roodt, Duncan Rowles, Vicky Saunders, Robert Seyfarth, Carol Sing, Peter Standfest, Subaru South Africa, Jenni Trethowan, Peter Twebaze, Ernst van Jaarsveld, Dave van Smeerdijk, James Varden, Quinton Vaughn, Ronald Wainwright, Graham Wallington, Lee White, Janine Willemans, Mike Woolford and all at Struik Publishers.

Adrian & Robyn

Contacts

The following companies and organisations hosted us in our travels across Africa. Between them they cater to a good cross section of budgets and have expert knowledge of the continent. Should you be considering travelling to the same or similar destinations, please contact one of them – they all provided excellent service:

Serengeti

Wild Frontiers: www.wildfrontiers.com
Tel: +27 11 702 2035; e-mail: wildfront@icon.co.za
Air Tanzania: www.airtanzania.com
Tel: +27 11 390 2664; e-mail: bookings@airtanzania.com
Holiday Inn Dar es Salaam: www.holiday-inn.com
Tel: +255 22 213 7575; e-mail: reservations@hidar.co.tz

Bwindi

Wild Frontiers: (see above)
Ngamba Island Chimpanzee Sanctuary: www.ngambaisland.org
Bookings through Wild Frontiers (see above)
Sophie's Motel, Entebbe:
Tel: +256 41 320 885; Fax: +256 41 320 897
Uganda Wildlife Authority: www.uwa.or.ug
e-mail: uwa@uwa.or.ug or gorilla.bmca@uwa.or.ug

Okavango

Travel Wild: www.botswanaholidays.com
Tel: +267 686 0822/3; e-mail: reservations@travelwild.com
Nxamaseri Island Lodge: www.nxamaseri.com
Tel: +267 687 8015/6; e-mail: info@nxamaseri.com
Guma Lagoon:
Tel: +267 687 4626; e-mail: guma.property@info.bw
Linyanti Explorations: www.linyanti.com
Tel: +267 625 0505; e-mail: info@linyanti.com

Namib

Wilderness Safaris: www.wilderness-safaris.com
Tel: +27 11 807 1800; e-mail: enquiries@wilderness.com
Air Namibia: www.airnamibia.com.na
Tel: +27 11 390 2876/7; e-mail: jhbreservations@airnamibia.com.na

Zambezi

Natureways Safaris: www.natureways.com
Tel: +263 4 333 414; e-mail: enquiries@natureways.com

Table Mountain

Table Mountain National Park: www.tmnp.co.za
Tel: +27 21 465 8515/9; e-mail: tablemountain@sanparks.org
Solole Game Reserve: www.solole.co.za
Tel: +27 21 785 3248; e-mail: info@solole.co.za
Baboon Matters: www.baboonmatters.org.za
Tel: +27 21 783 3882; e-mail: jenni@cybersmart.co.za

Boda boda,
near Entebbe, Uganda

Struik Publishers
(a division of New Holland Publishing (South Africa) (Pty) Ltd)
Cornelis Struik House
80 McKenzie Street
Cape Town 8001

New Holland Publishing is a member of Johnnic Communications Ltd

www.struik.co.za / www.imagesofafrica.co.za

First published in 2006

Copyright © published edition: Struik Publishers 2006
Copyright © text: Robyn Keene-Young 2006
Copyright © photography: Adrian Bailey 2006, with the exception of
image on pages 118/119: © Michael Poliza 2006

Publishing Manager: Dominique le Roux
Managing Editor: Lesley Hay-Whitton
Editor: Alfred LeMaitre
Designer: Adrian Bailey
Cartographer: Megan Knox
Proofreader: Joy Clack

Reproduction by Hirt & Carter Cape (Pty) Ltd
Printed and bound by Craft Print International Ltd

All rights reserved. No part of this publication may be reproduced, stored in a retrieval system,
or transmitted, in any form or by any means, electronic, mechanical, photocopying, recording or otherwise,
without the prior written permission of the copyright owner(s).

ISBN 13: 9 781770 073944
ISBN 10: 1 77007 394 9
1 3 5 7 9 10 8 6 4 2

All images in this book are available as fine art prints from
www.baileyphotos.com